LOST
GUILDFORD

DAVID ROSE

AMBERLEY

First published 2019

Amberley Publishing
The Hill, Stroud
Gloucestershire, GL5 4EP

www.amberley-books.com

British Library Cataloguing in Publication Data.

A catalogue record for this book is available from the British Library.

ISBN 978 1 4456 9294 4 (print)
ISBN 978 1 4456 9295 1 (ebook)

Origination by Amberley Publishing.
Printed in the UK.

Contents

Introduction

Guildford is a town that has seen many changes over the past century and a half. Its growth has been almost non-stop since the mid-nineteenth century when the railways arrived. Previously, Guildford had been a small market town that had changed relatively little for centuries. With rail connections to all points of the compass, housebuilding quickened in Victorian times for the well-off and for ordinary people. This continued into the 1900s with the addition of businesses and new industries.

Housebuilding increased in the 1920s and 1930s, along with the construction of the Guildford and Godalming Bypass, amenities such as the lido and new schools, including Guildford Technical College in Stoke Road.

More homes were needed after the Second World War, so the Bellfields estate was built, followed by Park Barn and Bushy Hill in the 1950s. Expansion has continued in every decade since, and in 1974 the much larger borough of Guildford was created.

It was in the late 1950s and early 1960s that much change began to take place in Guildford town centre itself. Older buildings were cleared away and replaced by modern offices and shops. Guildford was fast becoming a boom town, with service sector firms moving in.

The creation of the University of Surrey, which received its royal charter in 1966, has brought more change. It too has continued to expand, with its Manor Park campus and its research park that has attracted businesses at the cutting edge of new technologies.

Inevitably, all of this change means that much has been lost – for good or bad. It is not only buildings that have disappeared; a whole way of life has gone forever.

Lost Guildford takes the reader back, looking at the town our forebears would have known. Shops, pubs, places of worship and notable buildings that have gone from living memory are included, as are once important and newsworthy events. A focus on the workplace and recreation time is featured too, giving an insight into daily life. In the spring of 2019 Guildford town centre was witnessing the closure of a number of shops and restaurants, with some new ones taking over. In pinpointing locations in older images within this book a number of occupants at the time of writing have been noted. In some cases it is unclear what the future holds for them and other businesses too.

A selection of the many photographs taken by the late Guildfordian David Salmon are also included within a specific chapter, with others throughout, courtesy of Geoff Burch, the custodian of this important collection.

Others who have kindly supplied the author with vintage pictures now used in this book include: David Bennett, Brian Burns, Ben Darnton, Eva Hockley, Holy Trinity Pewley Down School, Ade Morley, Ian Nicholls, Graham Richins, Chris Quinn, Martin Whitley, Michael Williams, The Spike Heritage Centre and especially the Guildford Institute.

I

A Long, Long Time Ago

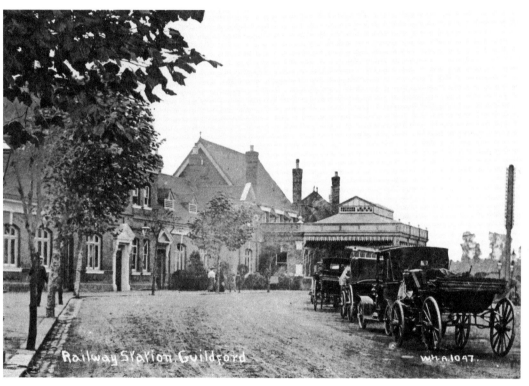

A glimpse of the entrance to Guildford railway station in the early 1900s. These buildings were from the 1880s when the station was largely rebuilt. To the right are taxi carriages and a motorcar. The ornate canopy, known as a porte cochère, was where well-off passengers alighted from their horse-drawn carriages.

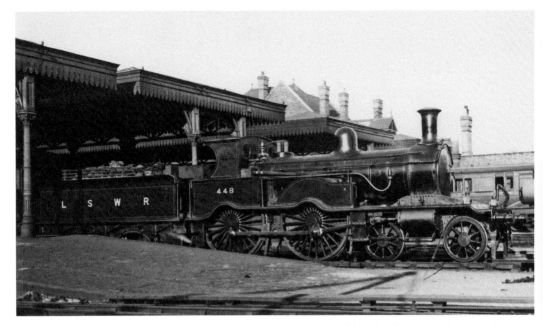

A London & South Western Railway locomotive waits to depart Guildford with a passenger train for Portsmouth in 1922. The London Waterloo to Portsmouth main line was electrified in 1937, doing away with steam-hauled passenger trains on that route. However, the steam train era continued until July 1967.

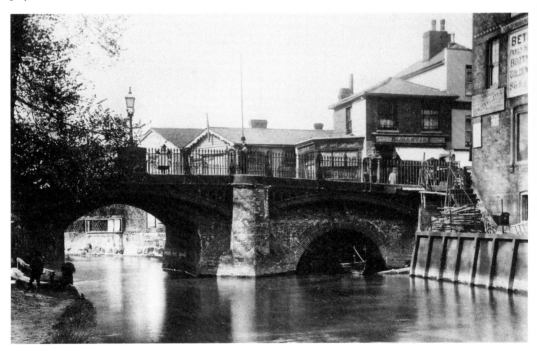

The crossing point of the River Wey has been at the foot of the High Street for centuries. Seen here, in the late nineteenth century, is the old stone bridge with three arches, which dated back to medieval times. It was widened and strengthened with iron arches and railings in 1824, and lasted until 1900.

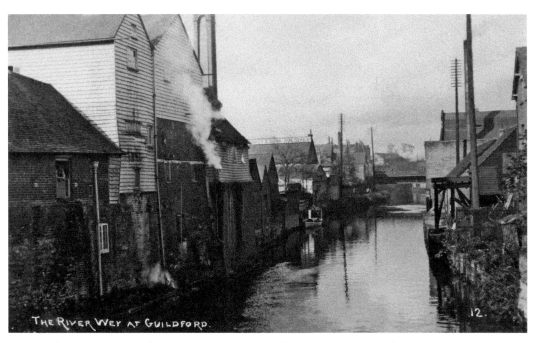

THE RIVER WEY AT GUILDFORD.

Looking downstream from the Town Bridge in the 1910s reveals just how industrial the riverside once was. Crooke's St Nicholas Brewery is on the left, while on the right is the town wharf with the now-preserved timber shed housing the treadwheel crane and hoist.

This small cottage is an indication of the houses that once existed in the centre of Guildford. It had been an alehouse known as the Three Mariners, and was also the birthplace of the town's most famous citizen, Archbishop George Abbot (1562–1633). It was pulled down in the 1860s and stood where there is a car park today, adjacent to the George Abbot pub near the Town Bridge.

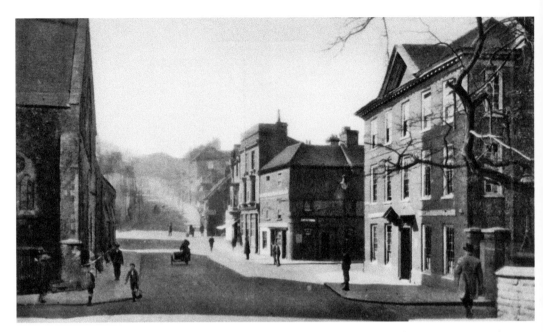

The High Street on the west bank of the river looking towards The Mount. The Queen Anne-style building on the right was the home of the Crooke family of brewers. When their brewery closed in 1929 the house became the unlicensed Connaught Hotel. It was demolished in 1942 and the site later became one of Guildford's bus stations.

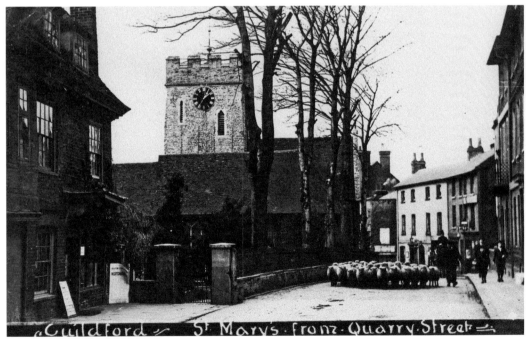

A scene that surely will never happen again: sheep being driven along Quarry Street! Captured here and published as a picture postcard in the 1900s, this would have been a common sight back then – Guildford being an important market town for west Surrey.

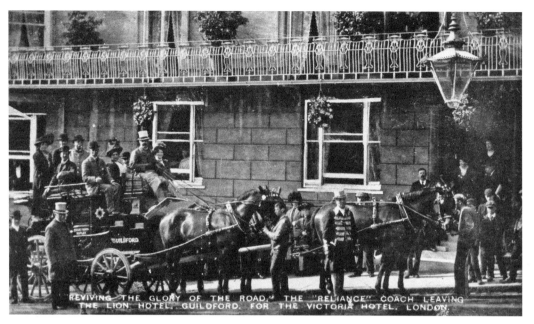

The heyday of the coaching age was the early 1800s when twenty coaches a day passed through Guildford. The inns prospered too, but the era was short-lived with the coming of the railways. However, there was a brief revival towards the end of the nineteenth century into the early 1900s. Here the Reliance coach is pictured leaving Guildford's Lion Hotel for the Victoria Hotel in London.

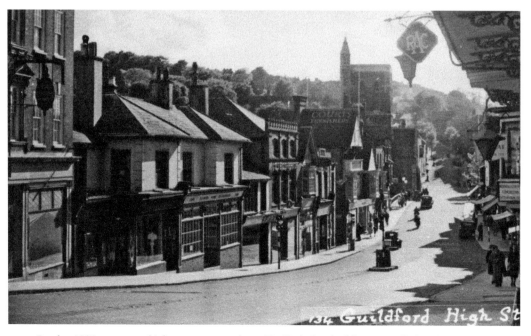

By the 1930s motor vehicles were everywhere. Traffic lights had been installed and, hanging from a canopy of the Lion Hotel, there is a sign for the RAC (Royal Automobile Club). This view, looking towards St Nicolas Church, is recognisable, but most of the buildings on the south side of the street have long since gone.

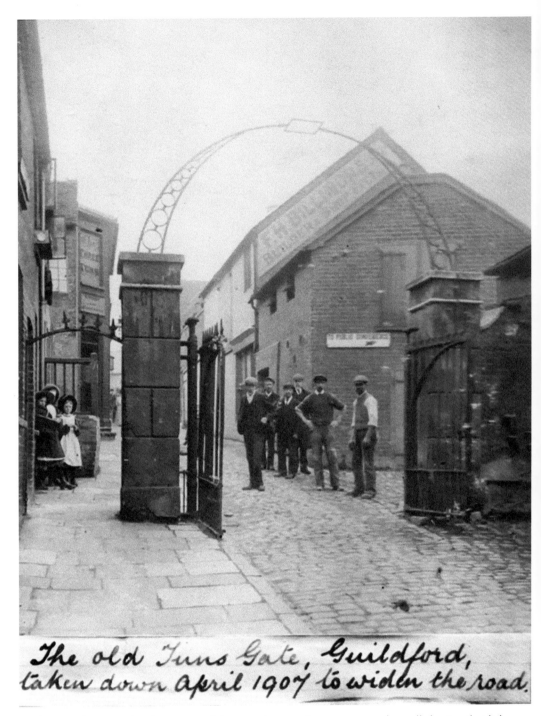

The old Tuns Gate, Guildford, taken down April 1907 to widen the road.

Looking up Tunsgate when it was one of the many lanes and passageways, often called gates, that led from the High Street. The gates and the posts were removed in 1907, while the buildings on the right must now be beyond living memory.

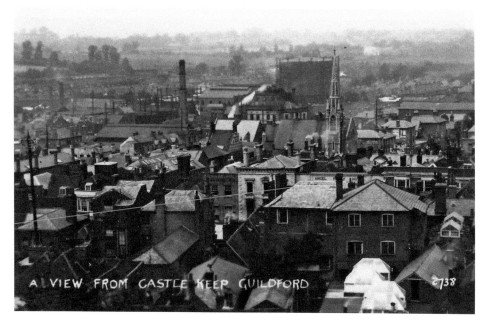

This was the view looking north from the castle keep around 100 years ago. Buildings and features that no longer exist include: the lantern lights of the Castle Street swimming baths (bottom right), the steeple of the Methodist Church in Woodbridge Road, the chimney and buildings of the Friary Brewery (now The Friary Centre), and the gasworks off Onslow Street.

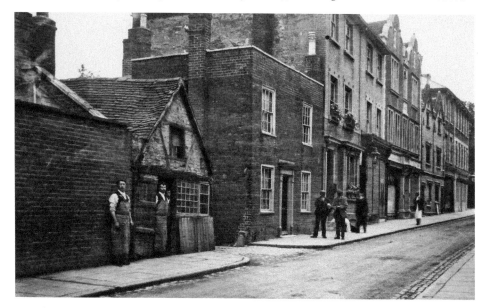

It is clear from this turn-of-the-twentieth-century view that what is today known as the upper High Street was once much narrower. The building furthest away is the clue to the location. At the time of writing it is the Jetty restaurant (once the White Horse Hotel) and part of the Guildford Harbour Hotel. Where the single-storey Lymposs' smithy was, with the crooked roof, is currently a building that in more recent times was a McDonald's, followed by other restaurants and at times unoccupied.

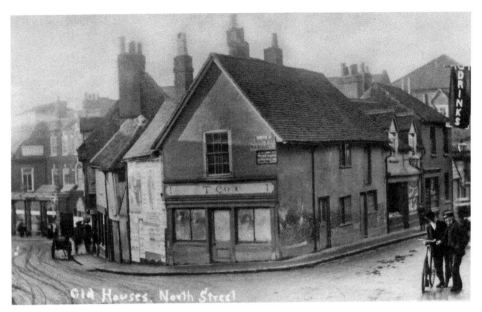

North Street is off to the left and Chertsey Street to the right, with a ramshackle group of buildings in between. In 1915 a pub called the Dolphin was built here (replacing an earlier one that had been close by in Cherstey Street). The building here today dates from the 1960s and is occupied by TGI Fridays and Turtle Bay restaurants. It was once a branch of the homeware store Habitat.

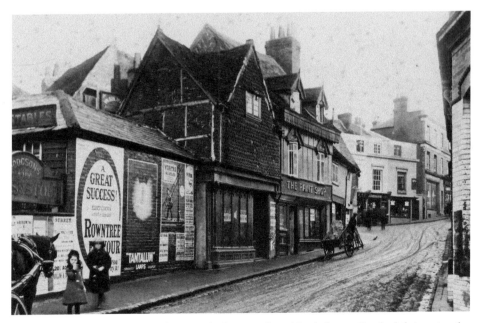

The same straggle of buildings, this time looking up from North Street. On the left is a sign for stables that belonged to the Dolphin pub – the pre-1915 one. The advertising posters are from long-gone products and include Rowntree's Elect Cocoa, introduced in 1887; Tantallum Lamps, short-lived in the early 1900s; and Vertias, a firm of German origin with a factory in London that made gas mantles, wicks and candle lamps.

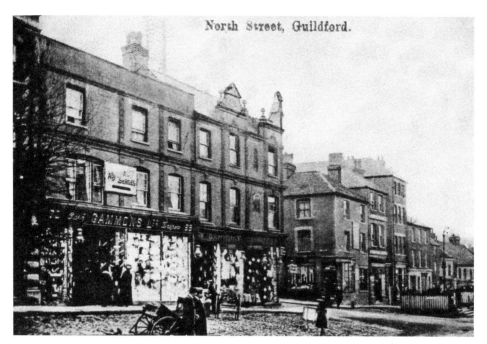

With Market Street entering between the buildings on the left, this view of North Street shows Gammons' drapery store, which was established in Guildford in 1878 and remained until the 1960s. Although appearing somewhat faint in this 1900s picture, a gantry can be seen above the roof of Gammons. Wires were attached to it, as the town's telephone exchange was once hereabouts.

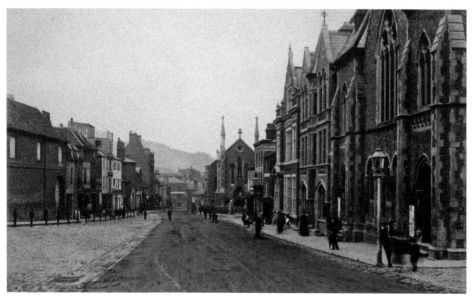

Looking down North Street, this picture dates to the late 1880s and very few buildings seen here remain. To the right the Congregational Church can be seen on the corner of Leapale Road, with its hall next door. Further down is the post office, while on the corner with Woodbridge Road is the Methodist Church. Built in 1844, it was later regarded as not fit for purpose and therefore pulled down and replaced in 1894.

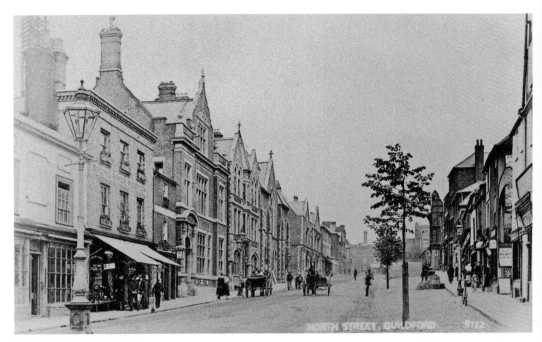

Another view of these buildings, often lamented as being rather elegant, this time looking up North Street. Most were demolished during the 1960s and 1970s. However, at least two remain – those nearest on the left. At the time of writing they were occupied by All Bar One and Guildford Cobblers.

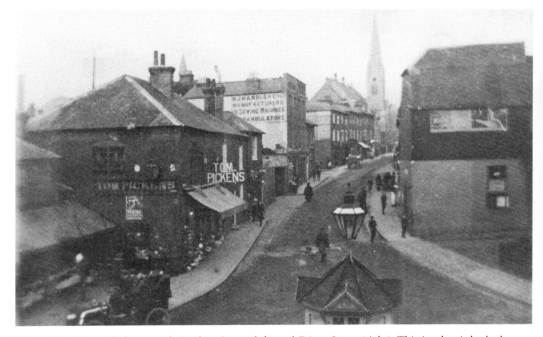

Where North Street links up with Onslow Street (left) and Friary Street (right). This is what it looked like as motor vehicles began whizzing through the town. Tom Pickens was a hardware store. On the site today is the entrance to The Friary Centre. The small hut seen at the foot of the picture at the junction of the roads was used by the operators of a public weighbridge that was once sited here.

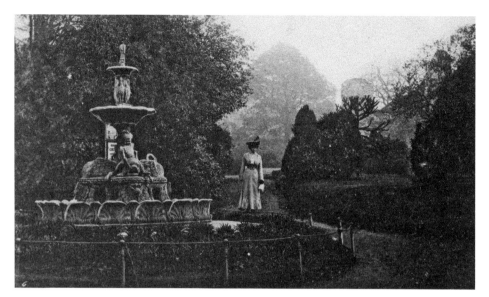

The Castle Grounds were purchased by Guildford Corporation in 1885 and made into a garden and public space, opened in 1888. Much of the original layout around the historic castle ruins, including the flower beds, lawns, bandstand and pond, plus the bowling green, have hardly changed, so are not really within the scope of this book. However, one feature, a superb fountain, disappeared many years ago. It was near the ground's entrance further down Castle Street.

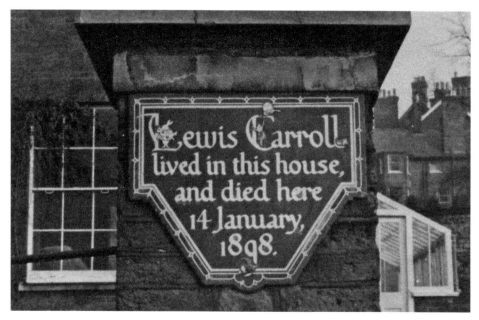

Many know that Lewis Carroll (Reverend Charles Lutwidge Dodgson), the writer of the famous *Alice* books, rented a house called the Chestnuts in Castle Hill for his six unmarried sisters. He often visited them from his home at Oxford. He died at the house in 1898 and is buried in The Mount Cemetery. In 1933 a memorial plaque was placed on a gatepost of the Chestnuts. Today the house is privately owned, and several years ago the plaque was removed for safe keeping, although appeals have been made to have it reinstated.

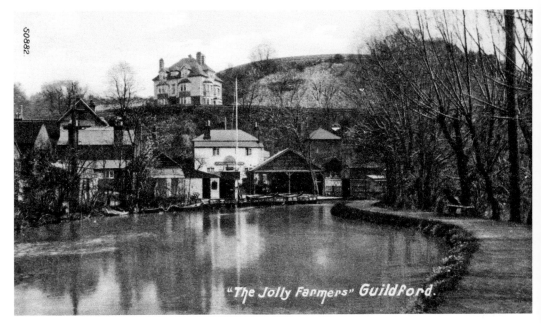

"The Jolly Farmers" Guildford.

Before Guildford had as many public parks and open spaces as it does today, the River Wey, upstream of the town centre, was the place to go for outdoor recreation. By the 1900s there were at least two firms hiring rowing boats and punts and offering river trips. Refreshments were also available and at the Jolly Farmer pub, seen here before it was rebuilt in 1913.

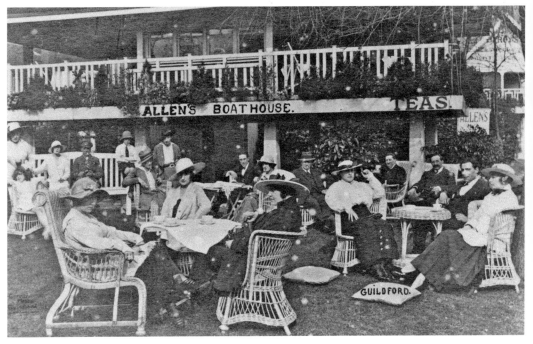

It looks like afternoon tea is being enjoyed at Allen's Boathouse in the early 1920s. This two-storey timber building still stands and has now been restored, but it is no longer a tearoom. The boathouse that was next door was Leroy's – a family who were originally from Belgium.

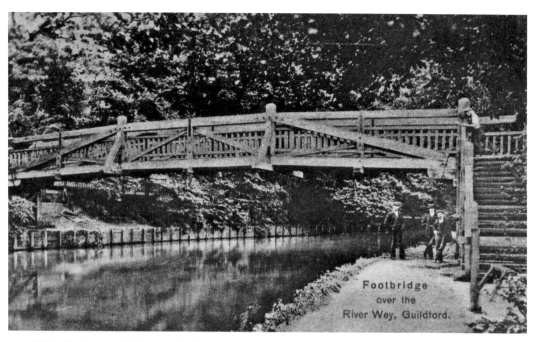

Footbridge
over the
River Wey, Guildford.

This timber footbridge was built over the River Wey upstream of the Jolly Farmer pub in 1909, presumably to give access for walkers from Shalford Road to the towpath. Unfortunately, the timbers rotted and it was replaced by the current bridge in 1934.

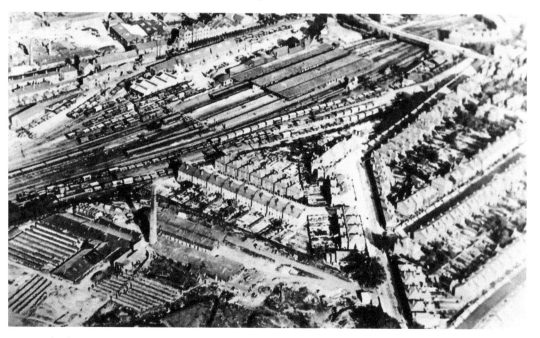

A bird's-eye view of the area close to the railway station sometime between the two world wars. Immediately striking is the sheer number of goods wagons in the sidings on both sides of the main tracks. To the lower left is the Guildford Park Brickworks. One of the last contracts for the works was making bricks for Guildford Cathedral, a short distance away on Stag Hill.

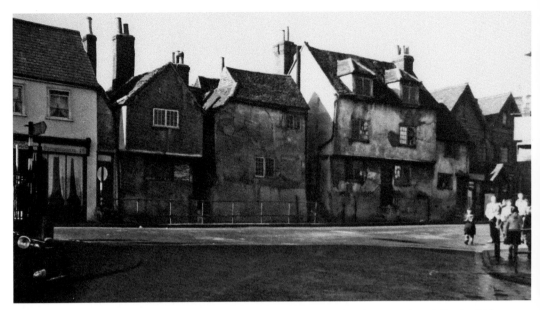

Finding good examples of really old humble cottages in Guildford today is rather difficult. Older buildings may hide behind façades added later or incorporated into developments years after. If these ones here had survived they may have become listed buildings. They stood in Park Street, along what is now part of the town's gyratory system. Seen here in the 1950s, neglected and dilapidated, they did not last much longer.

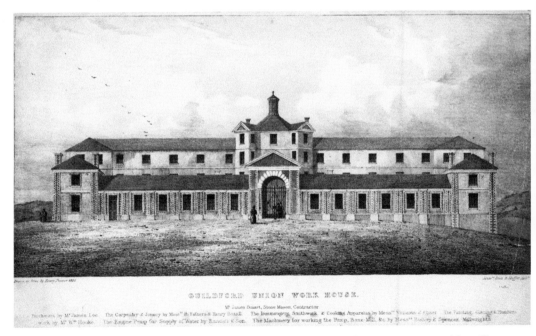

GUILDFORD UNION WORK HOUSE.

The Guildford Union Workhouse opened its doors in 1838 to those who were too poor, old or ill to support themselves. It was a harsh existence as it was perceived that those who were poor were idle. The workhouse regime of tedious hard work was designed to be a deterrent to paupers. Guildford's workhouse was built on open land to the south-east of the town centre in what today is Charlotteville.

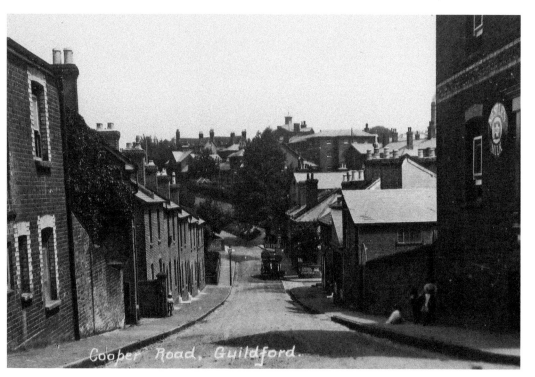

Photographs of Guildford's grim workhouse are extremely rare. Here it can be glimpsed in the distance in a 1900s view taken from Charlotteville. The workhouse era in Britain ended in 1930 and the site of Guildford's workhouse became St Luke's Hospital. The main workhouse buildings were demolished in 1965. However, the workhouse's causal ward for tramps and vagrants has been preserved as The Spike Heritage Centre.

2

Shops, Pubs and Hotels

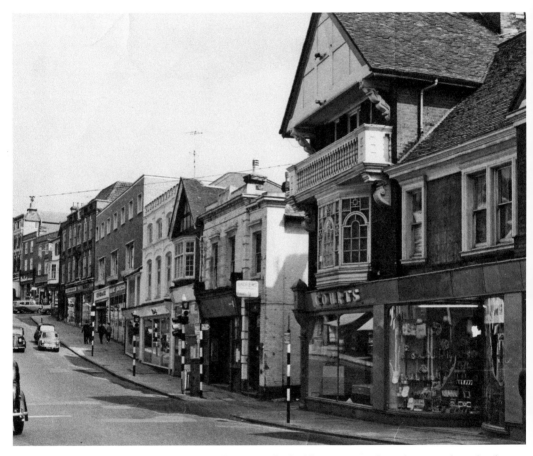

Starting at the foot of the High Street, by the 1950s the building seen on the right was a branch of Courts, the UK-wide furnishing business. Millbrook passes through here today while the building itself was demolished around the time Courts moved to Friary Street in the early 1970s. Courts had expanded into the Caribbean in the 1950s, but went into administration in 2004 when all its UK stores were closed.

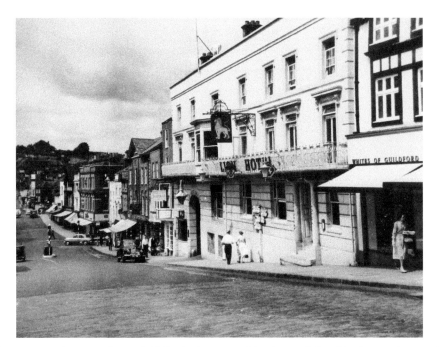

The Lion Hotel was, perhaps, Guildford's finest coaching inn and dated back to at least 1593. It thrived throughout the nineteenth century, but by the 1950s plans were afoot to develop the large site it occupied. It is pictured here not long before it closed in 1956 and was demolished the following year with a new Woolworths store replacing it.

F. W. Woolworth & Co. Ltd previously had a store further up Guildford High Street – on the opposite side, where WHSmith is at present. When it moved to its new premises it had entrances in both the High Street and North Street. As seen in this 1960s view, next door, formerly on the site of the Lion Hotel, was a branch of Dorothy Perkins ladies' wear. The site was redeveloped again in the 1980s, creating the shopping mall White Lion Walk.

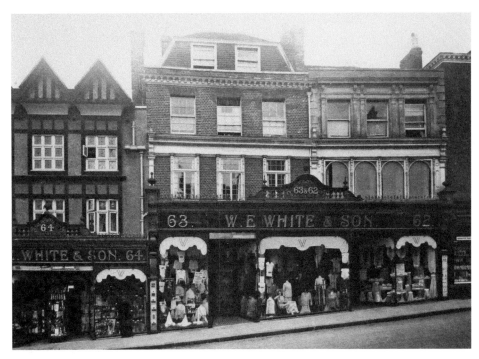

Next door to the Lion Hotel was the drapers W. E. White & Son. It was a family-run business in which the owners, for many years, literally lived over the shop. It succumbed to the redevelopment of the town centre, with Marks & Spencer buying the site for its new Guildford store, which opened in 1962.

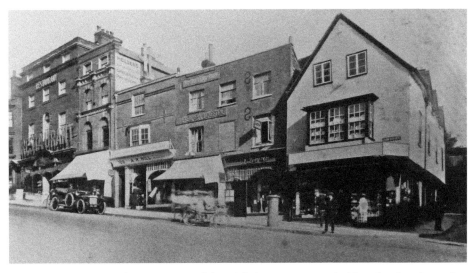

The buildings in this early 1920s view of the High Street are recognisable today, but the traders have certainly changed over the years. The shop on the corner with Quarry Street was then G. A. Perridge, selling china and glass. It was later a branch of WHSmith and then travel agents Thomas Cook. The shop with the fine car in front of it was the grocers Holdens. The painted lettering on the side wall of the building is still visible today – just! Further up was Brett's restaurant, which for now is WHSmith incorporating the town centre's post office.

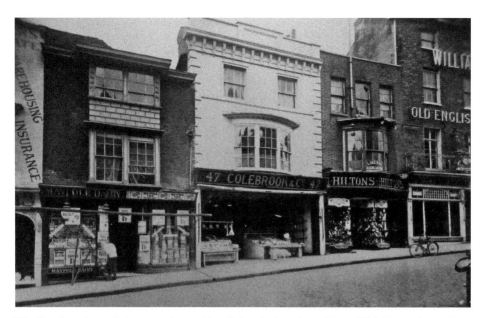

The first-floor bay windows are key to identifying the location of these High Street shops. They are currently occupied by House of Fraser, formerly Army & Navy Stores, and before that William Harvey's department store. At the time of this photo, around the 1920s, Hiltons sold boots, Colebrooke & Co. was a longstanding Guildford butchers, and the Maypole Dairy shop was next door.

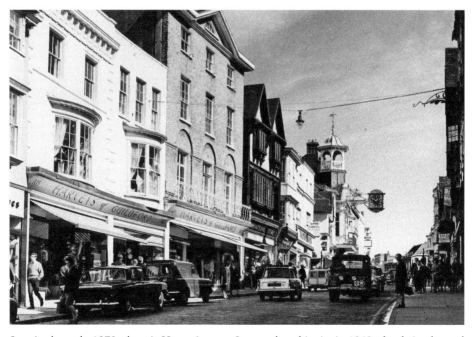

Seen in the early 1970s, here is Harvey's store. It moved to this site in 1948 after being located in the Playhouse Arcade on the opposite side of the High Street. The arcade later became the Tunsgate shopping centre, which in 2018 after major redevelopment, reopened as Tunsgate Quarter. Other lost shops in this view include International Stores and chemists Timothy Whites.

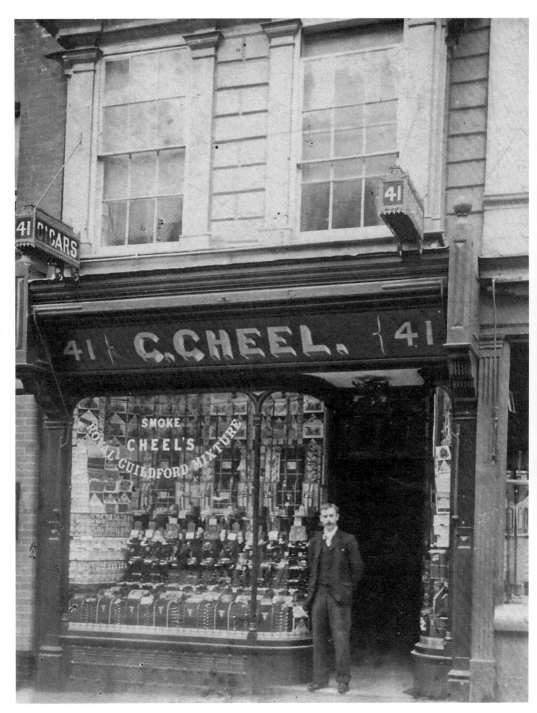

Trading for a number of years, Charles Cheel was one of many local people who had a shop in the High Street. Advertising his tobacco emporium in 1912 he boasted: 'Everything a smoker can want, of best quality, at lowest price.' He also offered the repair of pipes. The business was trading under the same name in the 1930s, but a G. A. Lambert and W. Read were its owners. The building is currently a shoe shop called Office.

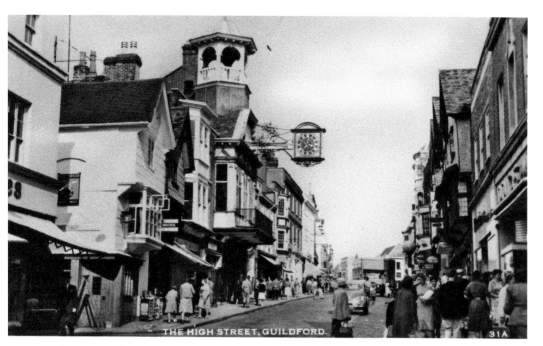

On the corner of High Street and Market Street was once the Bulls Head pub, seen here in around the early 1960s when it was owned by the brewers Whitbread. It was threatened with closure in 1973 when acquired by a developer who had plans to turn it into a restaurant. However, it was put up for sale again in 1976 and bought by two local businessmen who reopened it. Twelve years later they sold it to another developer and the pub closed for good.

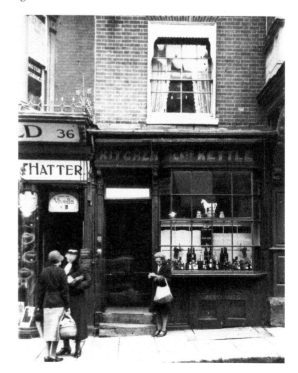

Next door to the Guildhall in the High Street was, at one time, a wine and spirit merchants called Kitchen Late Kettle. It is seen here in the mid-1930s. However, within a few years it had become a pub that went by the name of the Guildford Arms. It closed in the mid-1950s.

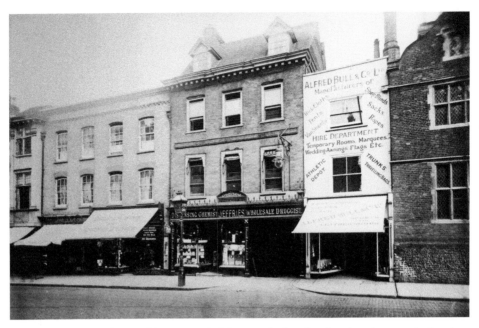

Jeffries Passage, bordering Abbot's Hospital, is named after the chemist who once had a shop there. Henry Jeffries established his business in Guildford in 1815. In this 1920s picture, next door was Alfred Bull & Co., makers of tents, blinds, ropes, sacks, awnings, flags, etc. By the 1960s that had become the premises of a tea and coffee retailer by the name of Importers. The smell of roasting coffee wafting into the street is still remembered.

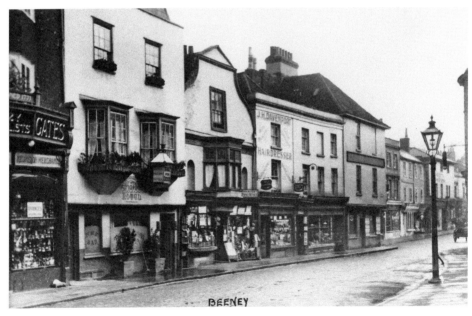

A much-changed view of the High Street opposite Holy Trinity Church. The building formerly Gates' grocery and dairy shop on the far left still exists, as does the Three Pigeons pub, but with a different façade, which was added after a fire in 1916. The others buildings, which included a post office, hairdresser and two further pubs (the Bell and the Ram), were pulled down in 1913.

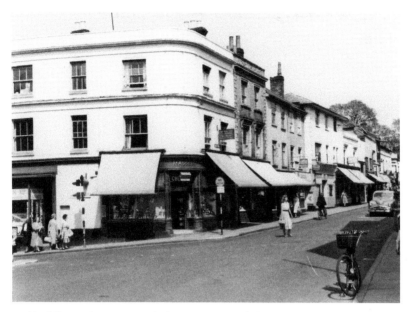

The curved building at the junction of Chertsey Street and the upper High Street was once known as Massey's Corner, as it was the premises of another local chemist, William Massey. Seen here in the 1950s, it was not long before all the buildings on this side of the street, up to Allen House (now the site of the Royal Grammar School's newer building), were demolished. Just behind the man on his bicycle what was then the town's art gallery can be seen.

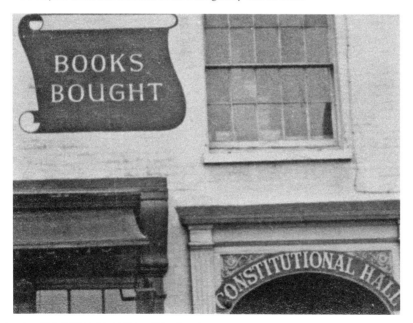

Just the sign 'BOOKS BOUGHT' will be familiar to many as Thomas Thorp's bookshop, at the top of the High Street, facing Chertsey Street. An Aladdin's cave of second-hand, new and rare books waiting to be discovered. The building, actual name Constitution Hall, was the site of Guildford's first cinema, West's Picture Palace, which opened in 1909. The building was sold by Guildford Borough Council in 2011, with many objecting to the sale of it owing to its history.

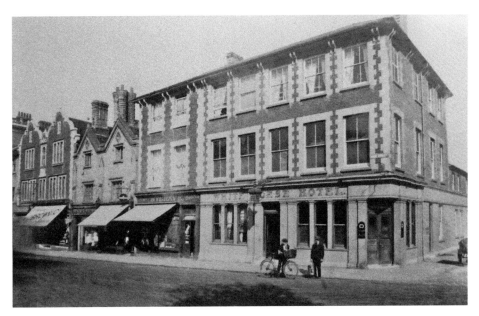

The building that became the White Horse Hotel at the top of the upper High Street dates back to the seventeenth century when it appears to have been a house. By the mid-nineteenth century it was not only offering accommodation but advertised 'a large room suitable for balls, concerts and public meetings'. Seen here in the 1920s, it was largely rebuilt in 1963 and is currently the Jetty, a restaurant that is part of the adjoining Guildford Harbour Hotel.

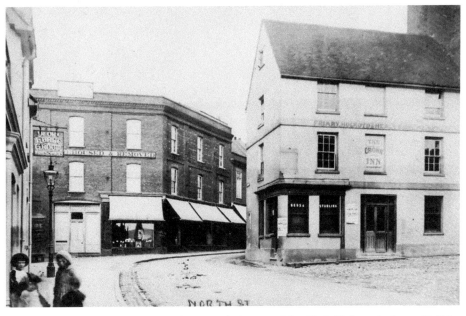

This is North Street. Just in view to the top right is part of the Cloth Hall, at the foot of Jeffries Passage. The Crown Inn, pictured here in the early 1900s, was soon to be pulled down to widen this part of the road. Up until 1838 it had been the workhouse for the poor of the parishes of Holy Trinity, St Mary's and St Nicolas. The mark on the gable end of the building can still be seen on the north end wall of the Cloth Hall.

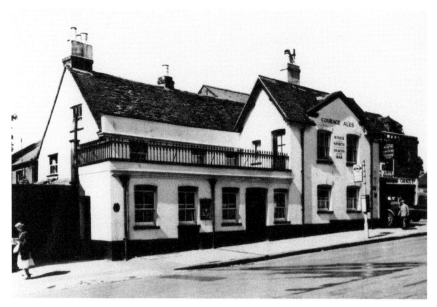

The Horse and Groom pub in North Street was where, on Saturday 5 October 1974, five people died and sixty-five were injured when a bomb planted by the IRA exploded. A second bomb damaged the Seven Stars pub in Swan Lane. The Horse and Groom reopened after a £500,000 refit, later changing its name to Grooms, but never really recovered from that infamous night. It is seen here around the 1950s.

After Gammons store had closed its premises in North Street new traders moved in, all of whom seen here in this picture from the 1980s have now gone. A family are looking at the menu outside the Market Tavern, which was on the upper floor. This was one of the once popular Berni Inns, a UK steakhouse chain founded by brothers Frank and Aldo Berni in 1955.

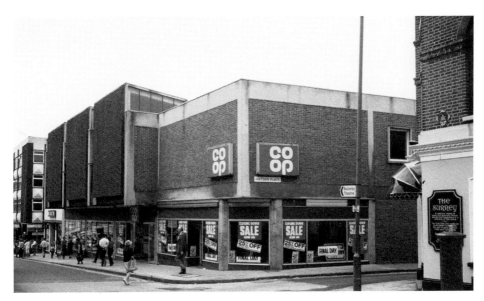

The Co-op was a feature of Guildford for many years and is seen here in its final days in the 1980s. The Guildford & District Co-operative Society was formed in 1891 and expanded throughout the twentieth century, occupying premises in North Street and along Haydon Place. It merged with the Royal Arsenal Co-operative Society (RACS) in 1971, but over the next ten years its department store and services were discontinued. The food hall, on North Street, was the last to go.

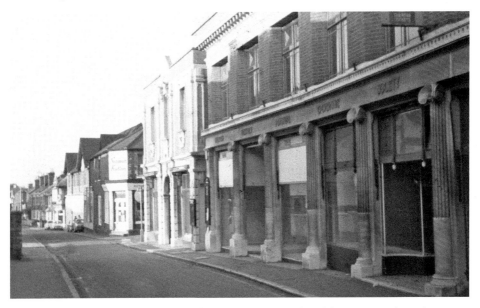

Looking along Haydon Place, the Guildford Co-op's Central Buildings are on the right. It was much more than a town centre department and food store as it had branches throughout the borough as well as in neighbouring towns. Not forgetting its milk, coal and bread delivery services, it once had an education committee that arranged children's groups and activities. In 1956, for example, sales amounted to just over £2 million and membership of those entitled to the 'divi' (a share of the profits) was 39,243 people.

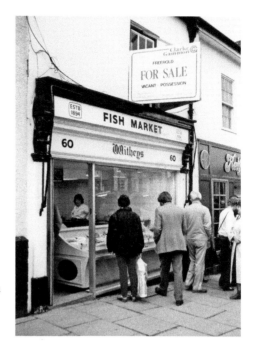

The south side of North Street once had a number of butchers and fishmongers. Butchers included Bernards, Vernons, Baxters and Matthews. The fishmonger W. E. George & Son was on the corner with Swan Lane, and at No. 60 was Witheys, which closed in the 1990s. The business was founded by Frank Withey, who was born in Camberwell, London, in 1861.

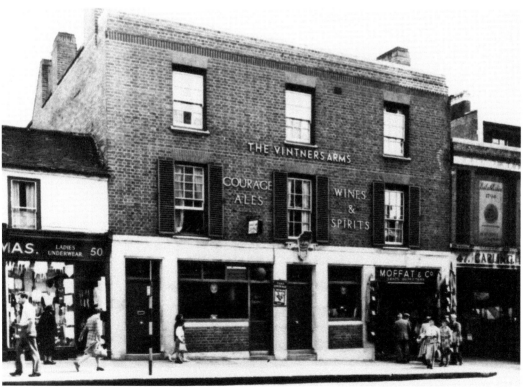

This building in North Street is still recognisable today with its shutters on the first-floor windows. Up until 1966 it was the Vintners Arms, dating back to the mid-nineteenth century, but much rebuilt after a fire in 1932. As seen in this 1950s picture, Guildford outfitters Moffats was trading from a shop here.

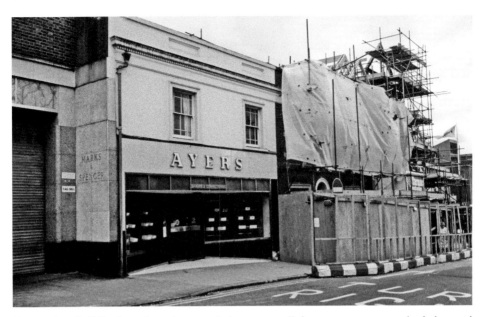

Yet another Guildford retailer who served the town well for many years was the baker and confectioner Ayers. It had several shops; the North Street one is seen here in 1985. Demolition taking place next door was the interior of the former Little White Lion pub and the F. W. Woolworth store, ahead of the creation of the White Lion Walk shopping centre. The façade of the pub has been retained.

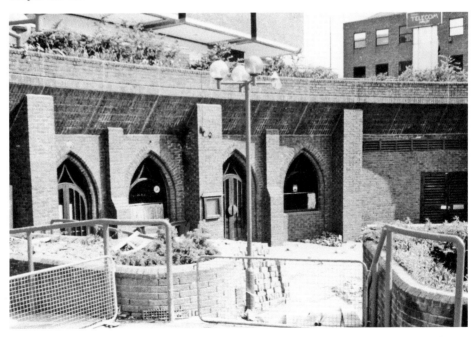

The Blackfriars pub was incorporated into the lower level of the Friary shopping centre when it opened in 1981. Named after the Dominican friary that was founded on the site in the thirteenth century, the pub, with its arched doors and windows, was not a success and lasted just seven years. It was converted into a number of retail units.

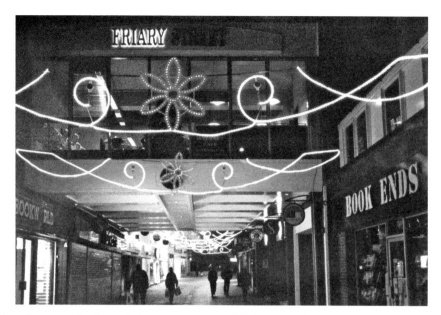

Friary Street, at the foot of the town centre and linking North Street and High Street, was pedestrianised and much altered at the end of the 1960s. It was partially covered with a building that at one time housed a popular eatery called the Danish Kitchen. Shops below once included Dixons, The Linen Company, Book Ends, Radio Rentals, Lloyds Bank and even a Tesco, later occupied by Woolworths.

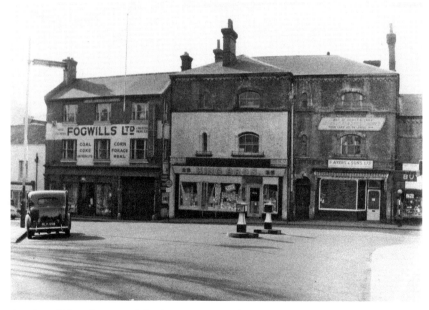

Here is where Friary Street and Onslow Street seamlessly met. Where the keep-left bollards are in this 1950s view is roughly where the open space usually called the Rotunda is now. Corn, seed and coal merchants Fogwills is still fondly remembered, while drapers King Bros also served the town well. Another of Ayers' bakers shops can also be seen in buildings that had once been barracks for the local militia.

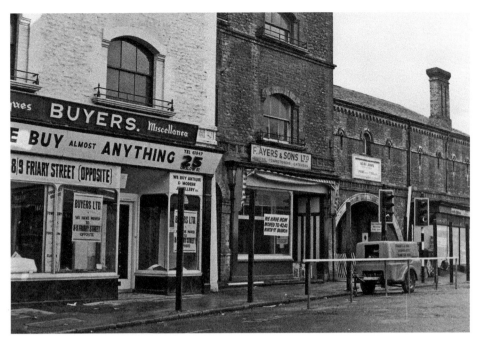

Also in the former barracks buildings was Buyers, a second-hand dealer with the slogan, 'We buy almost anything.' Pictured next door in this view had been another Ayres bread shop. On the far right is the arch where a path led to a footbridge over the river. Though much altered, it is still a public right of way. The sign for the once hugely popular Alby John dance school can also be seen.

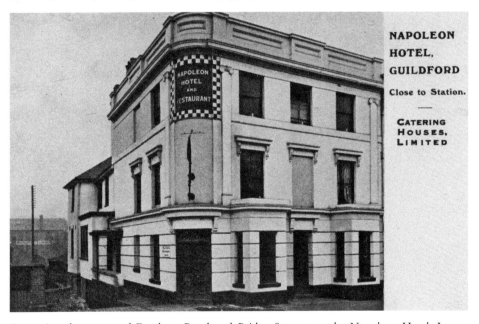

Occupying the corner of Farnham Road and Bridge Street was the Napoleon Hotel. It was named after the French emperor Louis Napoleon III, who was exiled in England after the Franco-Prussian War (1870–71). By 1978 it had become rather rundown and was closed. It was pulled down when the area of land around was developed in the late 1980s.

The east side of Farnham Road today features an office block beside the one-way system and river bridge. The Castle was once here – another pub dating from the nineteenth century. It was later owned by Courage, a large brewery and pub owner that itself has disappeared. However, some of its beers are still produced by the huge brewer and pub chain Charles Wells Ltd.

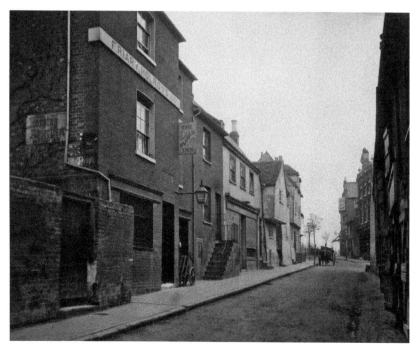

A little of what Farnham Road and Park Street once looked like can be observed in this view from the late nineteenth century. The pub on the left was the Plough. In more recent times it has had a succession of names, including Platform 9, Scrumptious and Divas. It is currently a DJ music bar called Thirty 3 Hertz.

The Wheatsheaf was another Courage pub, situated a short way up The Mount, off Portsmouth Road. It is reputed to have been frequented by drovers and farmers when they came to market, and back in the nineteenth century (according to contemporary newspaper reports) it was the haunt of robbers, conmen and highwaymen. All kinds of crimes took place there, including the passing of counterfeit coins and the making of illicit soap. The pub shut for the last time in 1955.

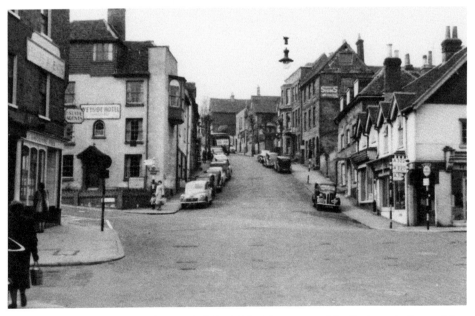

It is interesting to consider that the steep hill that is The Mount was originally the main thoroughfare in and out of Guildford to Farnham and beyond. On the left in this 1950s view is the Weyside Hotel, a temperance establishment that began as a coffee tavern in 1905. Halfway up the hill on the right was the Guildford Trades & Labour Club, which has now been converted into offices.

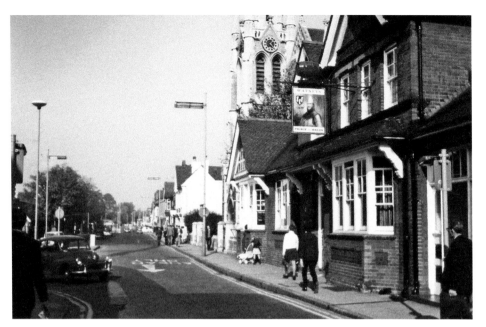

Woodbridge Road and the Prince of Wales pub, which stood next to St Saviour's Church. Going back fifty-odd years, Watneys pubs were not that common in Guildford as Friary Meux and Courage dominated throughout. Two generations of the Boyce family were landlords of the pub, which had a room for functions including weddings and parties. It was pulled down in 1972.

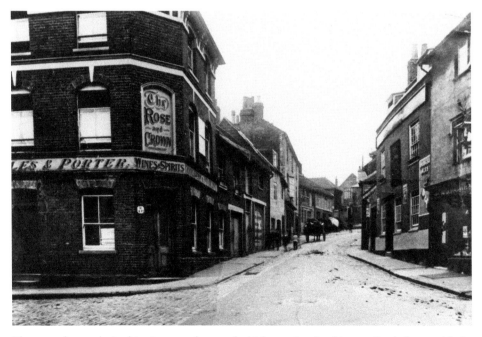

There are three pubs in this picture, only one of which remains. Looking up Castle Street with the junction of Chapel Street on the left is the Rose and Crown, which closed in 1916 and was later the Guildford Conservative Club. On the right is the Elephant and Castle (also gone) and just beyond the group of people is the Two Brewers – still a pub, and now called the Keep.

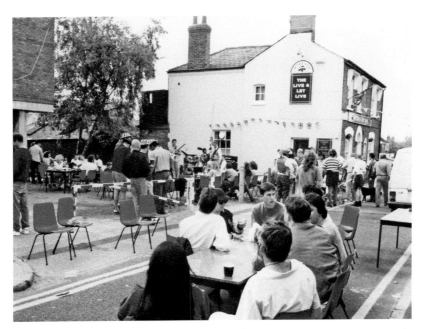

A street party is taking place in Haydon Place, possibly in 1995 to commemorate the 50th anniversary of the end of the Second World War. The small Live and Let Live pub appears to be doing a roaring trade with a band playing outside. All was to change in recent years as it had closed by 2012 and was demolished to make way for the Waitrose store development.

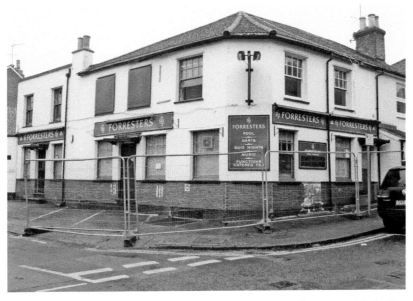

Boarded up and waiting for partial demolition and conversion into flats in 2013 is the Forresters pub on the corner of Cooper Road and Cline Road, Charlotteville. For some it was a sad end to a pub that had served its local community for 140 years. In 1870 it was called the Forester, then in 1871 it became the Forester Inn. In 1944 it became the Forresters Arms. For many years it had the unofficial name of the Pig and Tater. In 1976 that name became official, only changing back to Forresters for its last few years.

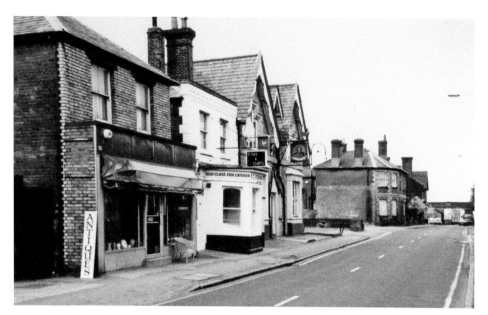

Although there is still a fish and chip shop in Stoke Road next to the Prince Albert pub, what's lost is the bay frontage it once had and the name 'R. C. Stevens High Class Fish Caterers' above it. Roy Stevens took over the business from his father Reginald. At one time Stevens had two further chippies in Park Street and South Street. Many who recall Roy frying and his wife serving, rated it as the best ever fish and chips for miles around.

F. Ayers & Sons Ltd had its bakery in Woodbridge Road, on the corner with Artillery Road. It was founded by James Ayers, who came to Guildford from London in the 1880s. Back in the 1960s at Easter time eight bakers would make 72,000 hot cross buns! The bakery foreman was a Mr Hambrook. All the other shops seen in this picture are no longer here as nearly all the buildings have been replaced.

3

Churches and Chapels

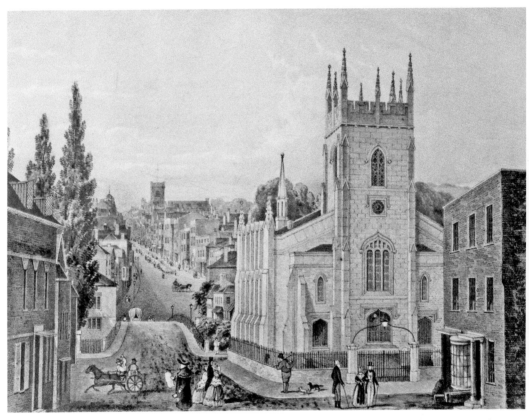

A church had stood at the foot of the town near the river for centuries, and it had most certainly often flooded. In 1836 prolific architect Robert Ebbels was commissioned to design a new church, but positioned at a higher level. It featured the then relatively newly invented concrete in its foundations. However, faults soon appeared, as well as it being dark and cramped inside. Forty years later it was replaced by the St Nicolas Church that stands today.

Guildford's Methodists built a church on the corner of North Street and Woodbridge Road in 1844. It was made of local Bargate stone with Bath stone dressing in the Early English style. However, worshipers found it very cramped and airless. It was demolished in 1892 and a replacement church with a tall steeple was built in its place, seen here when new. It lasted until 1962, when it was sold off, finally being pulled down in around 1973 and replaced by a branch of Barclays.

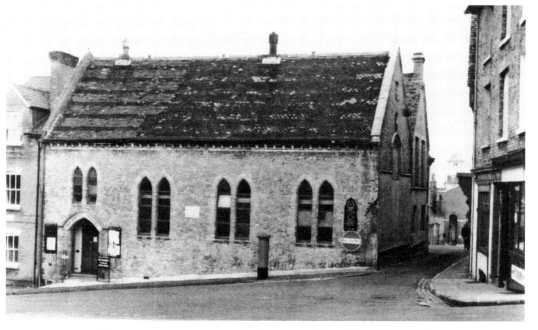

At the top of Tunsgate, where it meets Castle Street, stood the Old Baptist Chapel. Dating from 1860, it replaced an old barn previously used for worship by the strict and separate Baptists. Although threatened with demolition in 1937, it survived until 1954. It had a graveyard and the remains of those who laid there were exhumed and reburied in The Mount Cemetery. The congregation moved to a building in Chertsey Street, which is still in use today.

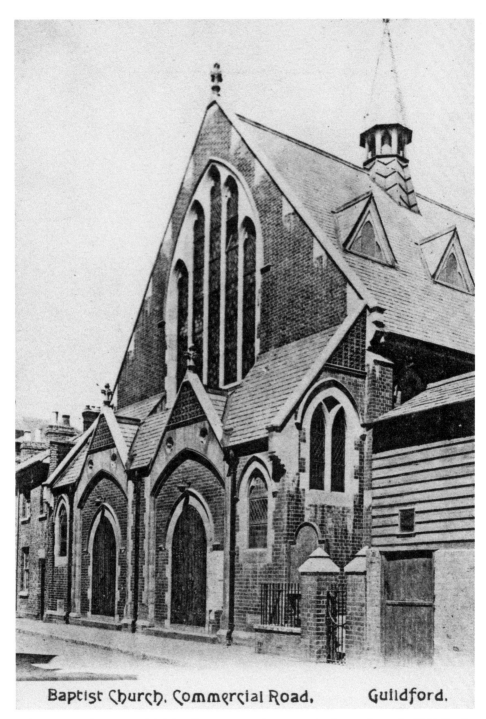

Baptist Church, Commercial Road, Guildford.

Other Baptists, known as Calvinist dissenters, met in a room in Quarry Street in 1824. By the mid-nineteenth century they had built a chapel in Commercial Road. Pastor David Pawson's arrival in 1968 heralded a period of growth, and in 1972 today's Guildford Baptist Church in Millmead was opened. Traces of the former church can be seen on a wall next to an open space opposite the bus station.

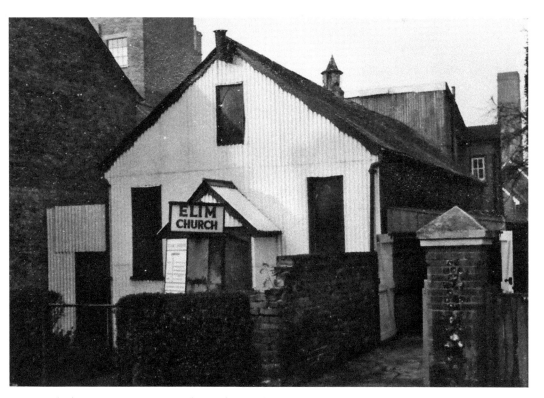

Tucked away in Martyr Road, on the north side near the Cherstey Street end, was this small corrugated-iron chapel. The Elim Pentecostal Church was founded by Welshman George Jeffreys in Ireland in 1915. Elim is mentioned in the Book of Exodus as an oasis found by Moses and the Israelites as they fled Egypt. Today in Guildford the Elim Penetecostal Church is represented by the New Hope Church in Larch Avenue, Bellfields.

In 1857, Roman Catholic Captain Francis Salvin, then owner of Sutton Place, allowed his chaplain to celebrate Mass every Sunday in a room over a shop in Guildford's upper High Street. In around 1852, land in Chertsey Street, next to the Bars, was bought by an Edward Collen of Albury as a site for a future Roman Catholic church. A wooden hut was first used and replaced in 1884 by the church seen here. In 1984 a new church was built in a corner of Foxenden Quarry, off York Road, with the spire from the old church added to the new one.

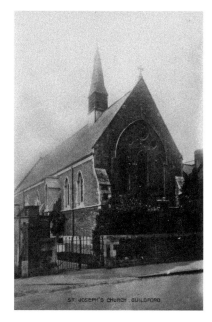

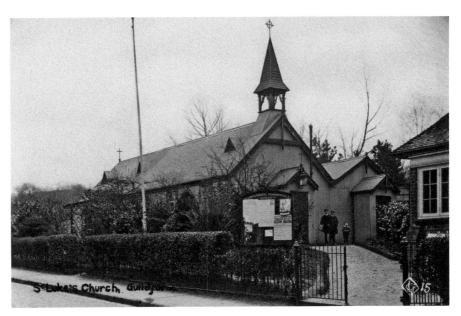

A chapel clad in corrugated iron and known as 'Tin Tabernacle' was erected in Addison Road, Charlotteville, in 1895. Named St Luke's Chapel, it served the community well and its name was adopted when Warren Road Hospital changed its name to St Luke's Hospital in 1945. The chapel was demolished in the 1960s to make way for Addison Court, which provides affordable sheltered housing for elderly people.

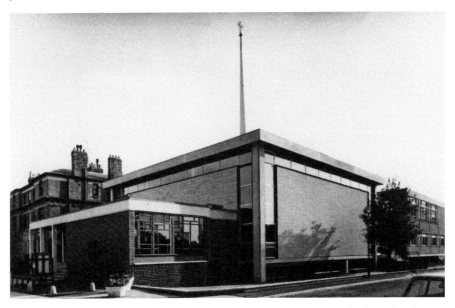

Pictured soon after completion in 1966, this is the Guildford Methodist Church that replaced the former church in the town centre. This building stood in Woodbridge Road on the corner of Wharf Road near the sports ground. In 2013 its congregation joined the Anglicans at St Mary's Church in Quarry Street. Guildford's Methodists also share worship with the Salvation Army, Russian Orthodox, Roman Catholic and other churches. The building was demolished in 2016 and apartments are now on the site.

4

Guildfordian and Photographer David Salmon

David Salmon was a well-known character, often seen around Guildford with his camera photographing the changing scene as well as events and local people. He lived all his life in Artillery Road, apart from three years in the RAF during the mid-1950s when he did his national service. He took thousands of photos during his lifetime, not only local views, but the types of transport that had fascinated him since he was a young lad – namely trains, buses and aircraft. He was also a keen road-racing cyclist and competed for Guildford's Phoenix Cycling Club.

When Dave left Stoke Secondary Modern School aged fifteen in 1952, he joined British Railways at Guildford's Motive Power Depot as an engine cleaner, a year later passing his training to fire steam engines. National service interrupted his progression as a railwayman, and when he rejoined the railway he had to start again as a cleaner. In 1960 he quit and became a painter of road signs, a job he did until retirement. It is from this work that he was nicknamed 'Dave the Brush', also being known simply as 'Dave' and even 'Sam'. This chapter focuses on his photography.

 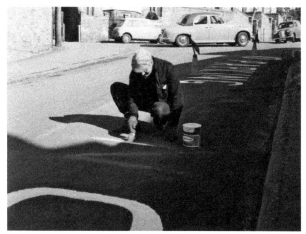

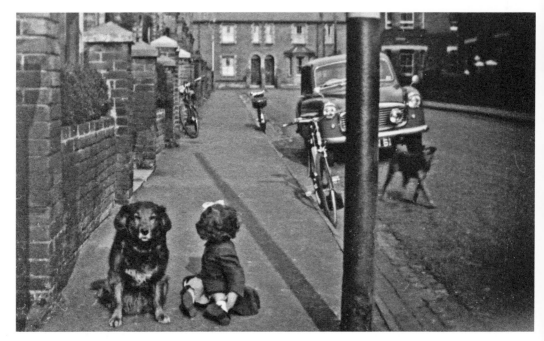

Artillery Road captured as a moment in time by Dave towards the end of the 1950s. A child and a dog sit on the pavement, bicycles are propped up against the kerb and just a solitary car is parked in the road. Otherwise, the houses look much the same.

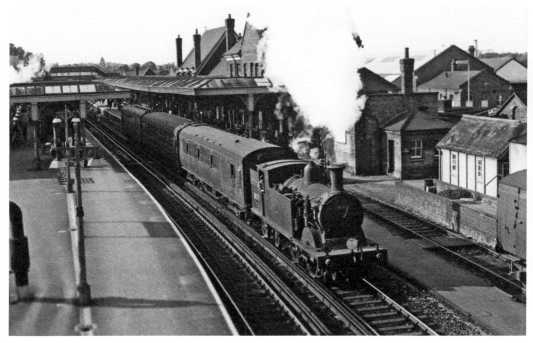

In the final years of steam trains in the 1960s Dave extensively photographed engines at Guildford and further afield, even as far as the north-west of England. Taken from the Farnham Road bridge in 1961, a three-coach train departs Guildford for Horsham, hauled by M7 Class 30378.

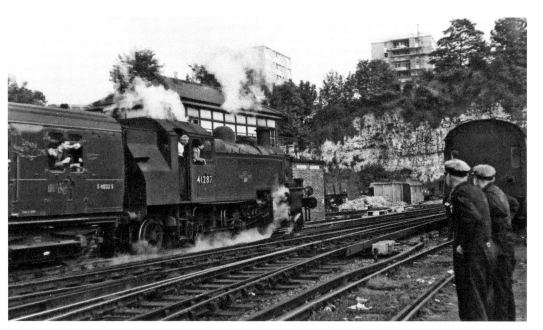

The 7.34 p.m. passenger train from Guildford to Horsham on 12 June 1965 was the last scheduled service over the line – it was axed as part of the Beeching Report into the UK's railways. Dave was at the line side by the engine shed to record the moment. Fitter Ernie Pitman and a colleague look on, but who is the woman leaning out from the engine's cab door?

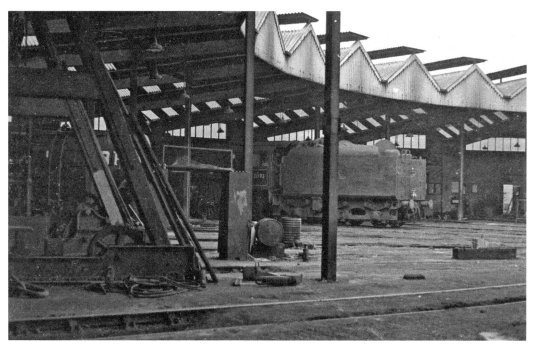

Guildford's semi-roundhouse engine shed was at the 'country' end of the station by the entrance to the tunnel. As a former railwayman Dave had easy access to it. His superb monochrome images capture the atmosphere of a place that would soon be no more.

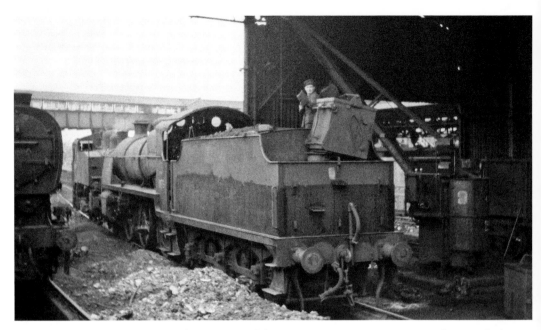

The coaling stage was closer to the station and here, on 28 January 1966, Dave photographed something unusual. Although railwayman Steve Burke appears to be loading an engine, in fact he is removing coal from the tender of N Class 31873, as it was about to be hauled away to be scrapped. This is evident as the driving wheels' coupling rods have been removed.

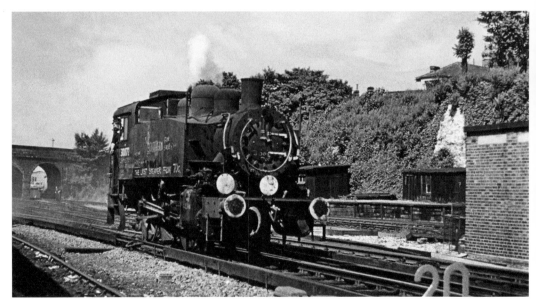

Sunday 9 July 1967 was the very last day of steam on the Southern Region of British Railways. USA Class 30072 was the final engine to leave the Guildford depot that summer afternoon. Dave took this picture as she heads for the tunnel. Destination: Salisbury via Havant and Fratton. The blue haze surrounding the engine is from exploding detonators attached to the rails to hail a last farewell. The West Ham United football scarf on the smokebox door may well have been Dave's, as it was the team he supported.

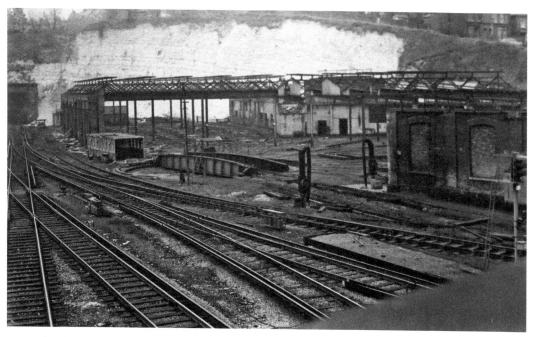

The depot is seen here in 1969 while demolition was taking place, viewed from the Farnham Road bridge. Much of the asbestos roofing has been removed, while the turntable is still in place, as are a couple of water columns on what were known as the old and new pits.

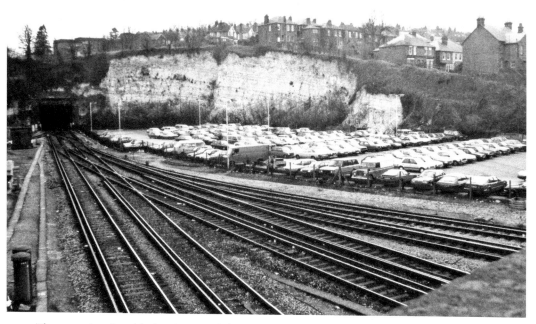

The same view, but this time in around the 1980s with cars where there had once been steam engines. It would not be long before the Farnham Road multistorey car park was built here. At its pedestrian entrance from Farnham Road a commemorative plaque was unveiled on 9 July 2017 – fifty years to the day when the steam depot closed. Former railwaymen and train buffs forever know it by its shed code: 70C.

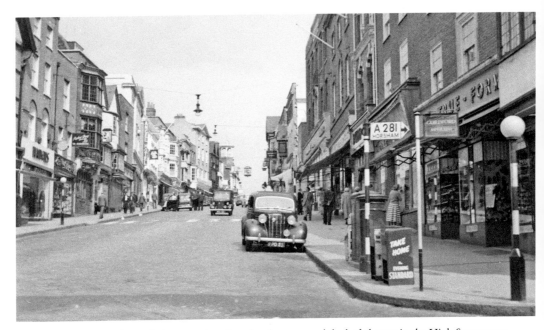

The buildings may look much the same, but there has been a good deal of change in the High Street over the past sixty years. Street lamps were once strung above the road on wires, and there were pedestrian crossings and metal bins containing newspapers. Note the old-style road sign, with this one pointing towards Horsham, and a sign for Guildford Museum.

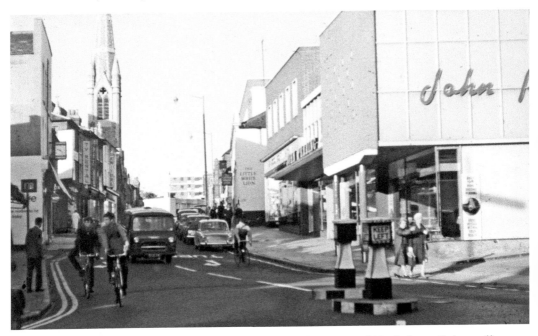

Back in the 1960s one-way traffic of all kinds went down the lower part of North Street. Today traffic flows the other way and is restricted to buses, taxis and service vehicles. The furniture store John Perring was on the right, next to it Woolworths, with the Little White Lion pub also in view. The keep-left bollards look much more imposing than the style used today.

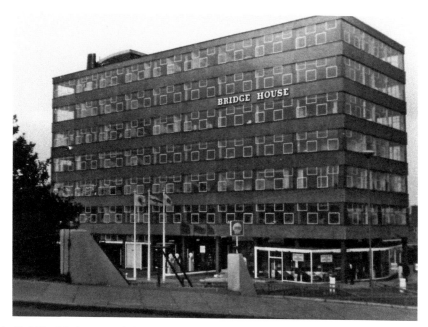

With Guildford being regarded as Surrey's boom town by the early 1960s, Bridge House was among its bold new buildings. The office block stood on the corner of Bridge Street and Walnut Tree Close. At ground level was a petrol station. It was pulled down in around 1988, replaced by a new Bridge House development.

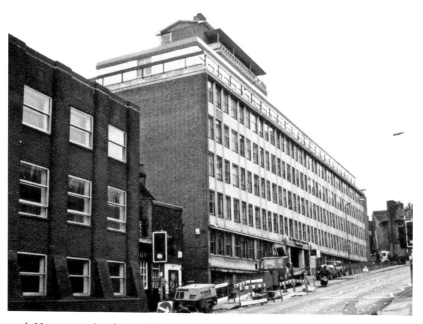

Burymead House, at the foot of Portsmouth Road, was offices of the Central Electricity Generating Board until the late 1980s, after which it was demolished. Since then the site has laid empty, reminiscent of a post-war bomb site, with weeds gradually colonising the rubble-strewn space, surrounded by dull hoardings and becoming shoddier by the day. This is despite plans for various new developments, the most recent being apartments for older people.

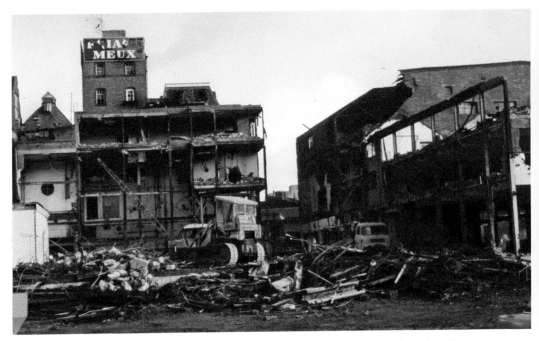

The demolition of the former Friary Meux brewery complex to make way for The Friary Centre was captured by Dave Salmon in 1974. The brewery had been established in around 1870 and expanded on the site in the years that followed. Along with its many pubs in the Guildford area and beyond, it had employed a large number of local people.

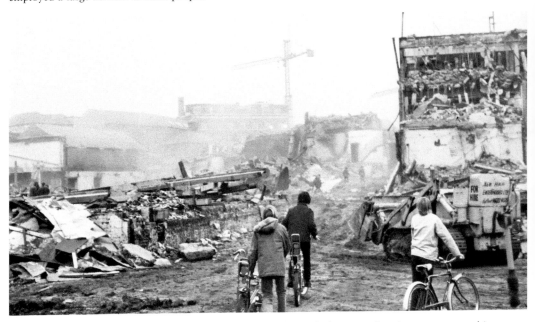

Demolition and building sites were once easy to access while work that was often dangerous was taking place. Dave's amazing photo features a group of boys (two with Raleigh Chopper bikes) making their way through the former Friary Meux brewery site as demolition and clearing the area continues with a smoky haze in the air.

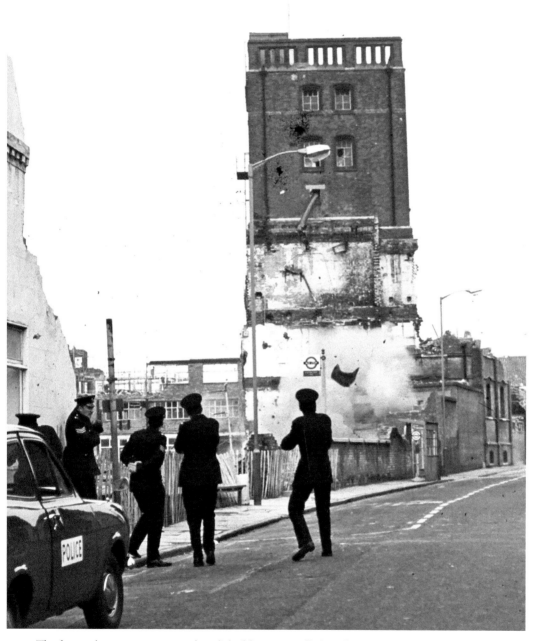

The former brewery tower was demolished by a controlled explosion on a Sunday morning in 1974. People gathered close by to watch the spectacle, not least Dave Salmon who perhaps stood closer than most! The policemen are recoiling somewhat at the very moment the explosives at the base of the building go off.

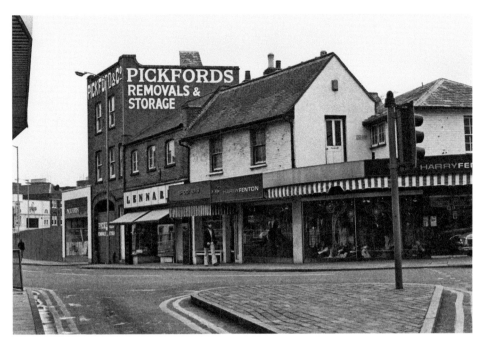

Some of the buildings where Onslow Street joins North Street remained for a few years after the main Friary site had been cleared. Included here are outfitters Harry Fenton, florists Spooners and shoe shop Lennard. A taxi rank occupies part of the road here today.

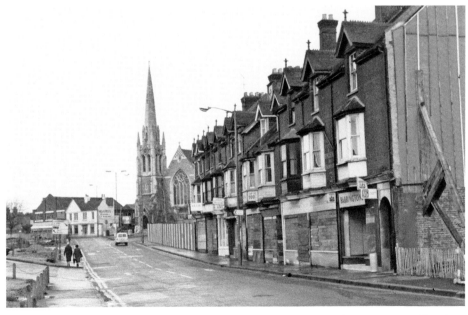

Onslow Street is almost devoid of vehicles, seen here looking towards St Saviour's Church in Woodbridge Road. The boarded-up buildings on the right would soon be gone. The last shops included newsagents Babbingtons, bookmakers Heathorns, gents outfitters E. Diamond as well as a branch of the Oddfellows society. The service entrance to the Friary shopping centre occupies part of the site today, with an office block on the far corner.

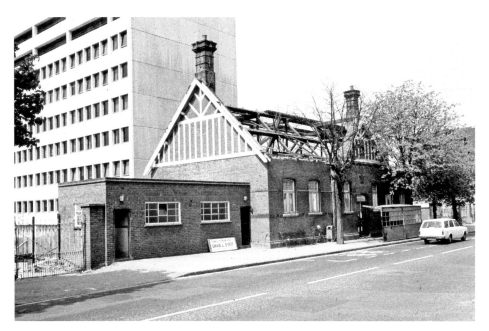

The old and the new pictured together. This is Woodbridge Road and in the foreground is the former corn exchange building that was part of the cattle market. It is seen here being demolished in 1976. Behind it rises the then bright white Guildford police station, which had been built a couple of years previously.

'Offices to let' proclaims the estate agent's sign on the Municipal Offices building that stood in the upper High Street on the corner with Eastgate Gardens. Pictured here by Dave in 1982, these had been used by Guildford Borough Council before it relocated to Millmead. The Eastgate Court development of offices and shops is on the site today.

By the end of the 1980s there had been a huge transformation of the area around Guildford railway station. Dave Salmon took a series of pictures before, during and after the changes. Among the shops that lined Station Approach was stamp dealers G. H. Bain & Sons and Malcolm's, a ladies hair salon.

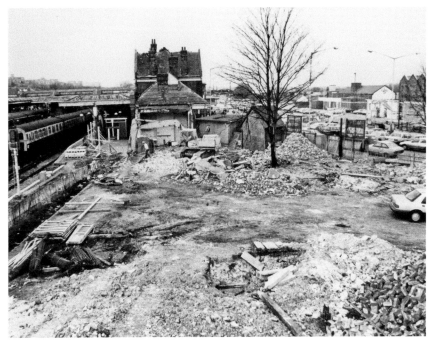

The Station Approach shops and other buildings close by have been pulled down in this view, but with a couple of trees still awaiting their fate. Roof tiles have been removed from the main station building and work has begun on its demolition.

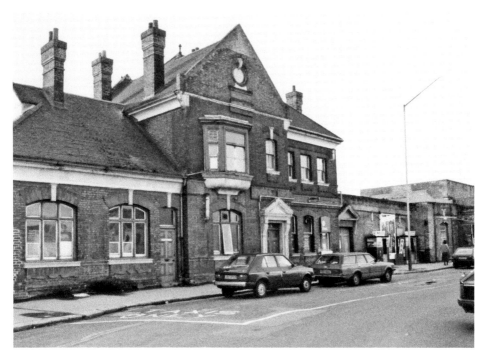

With doors and window frames still painted in BR Southern Region green, the station building was still in use when this picture was taken. The passenger entrance was further along to the right, while in view here is a sign above a kiosk and two booths for instant photographs.

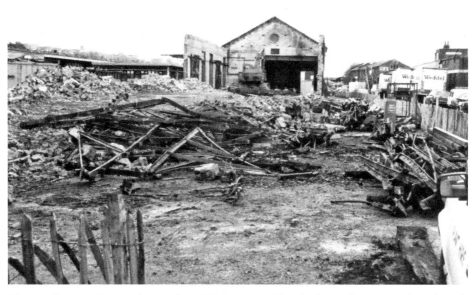

The area between Station Approach and Walnut Tree Close had once been a goods yards with railway sidings. A number of firms had depots here. In 1974, for example, was the *Evening News* and the *Evening Standard*, corn merchants Burwood-Farm Ltd, meat suppliers W. Weddel & Co. Ltd, and Steve Chitty. Further along was timber merchant John Moon & Son Ltd.

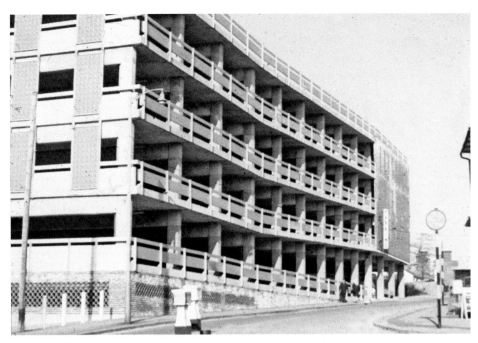

With an ever-increasing number of cars being driven into Guildford, a multistorey car park was opened in Sydenham Road in 1963. It was a building designed to be functional rather than aesthetic. The exit was via a curved sloping ramp. In the late 1990s the building was found to be structurally unsafe and was demolished to be replaced by today's multistorey Castle car park.

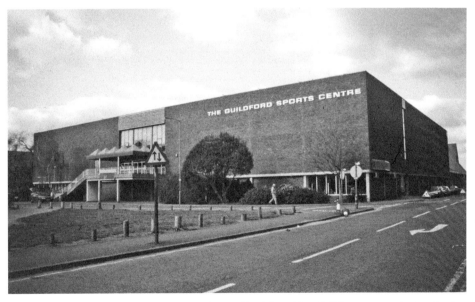

When the Guildford Sports Centre opened in Bedford Road in 1972 it was a revelation, having three pools, squash courts and a hall (popular for five-a-side football and badminton), plus a viewing gallery. The upstairs bar and cafeteria was also well used. Twenty-one years later it was superseded by the much larger Spectrum leisure centre in Stoke Park. The Odeon cinema now stands on the site of the former sports centre.

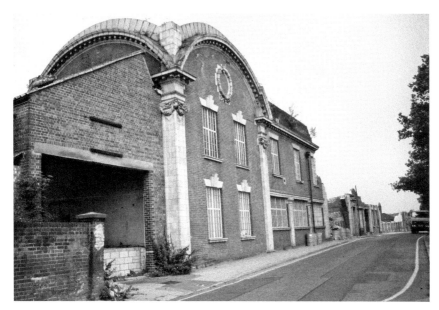

Another landmark building Dave Salmon photographed during demolition in the late 1980s was the frontage of the factory belonging to specialist vehicle firm Dennis Bros, which faced the railway line at the foot of Woodbridge Hill. This is now the Midleton Industrial Estate Road, while the Guildford Business Park now occupies the former factory site.

There were few buildings in and around the town centre of some importance that Dave Salmon did not photograph when faced with demolition. Seen from the Bars, off Haydon Place, is the back of the Sandfield Terrace Drill Hall. The corrugated-iron and timber building was acquired second-hand from Edinburgh by the Queen's Royal (West Surrey) Regiment in 1891 for use by its volunteer troops. Throughout its history it was not only used for military purposes, but also for community activities, in particular being a very popular dance hall.

5
Special Events and News Items

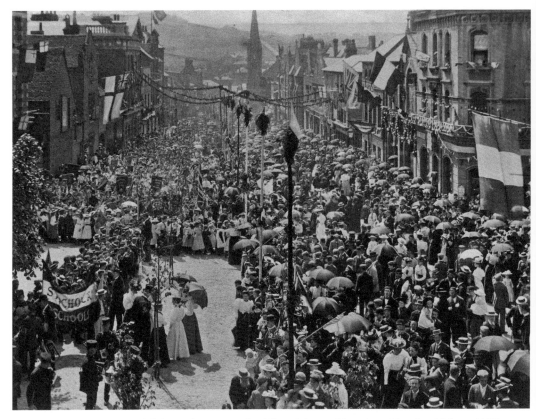

Crowds fill North Street to celebrate the Diamond Jubilee of Queen Victoria on Tuesday 22 June 1897, with a grand procession through the town. The previous Sunday was observed as a day of thanksgiving in commemoration of 'Her Majesty's long and beneficial reign'.

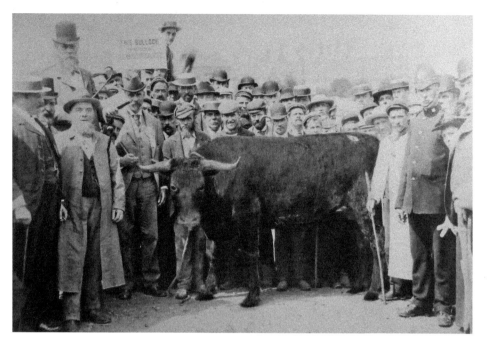

Guildford's cattle market that had been in North Street moved to a new site in Woodbridge Road on 16 June 1896. A commemorative photograph was taken featuring the first bullock that was sold on that day. The beast was bought by a Mr R. Shillingford.

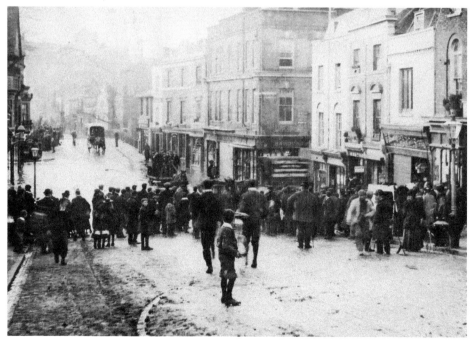

In February 1900, rain and thawing snow caused the River Wey to burst its banks and flood the foot of the High Street. In this picture crowds have gathered to witness the scene and horse-drawn vehicles are passing over the Town Bridge and through the floodwaters.

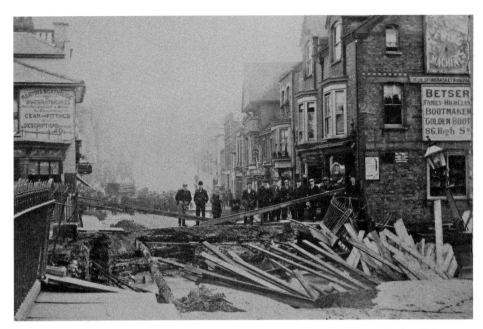

The force of the water began to wash sawn timber downstream from the nearby flooded Moons timber yard. The arches of the old bridge became blocked, with the result that more water was forced against it and the main arch crumbled and collapsed. It was two years before the bridge was replaced.

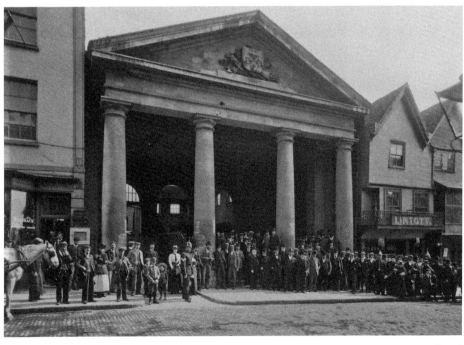

On 18 May 1901 the corn market, which had been at Tunsgate for nearly 100 years, was transferred to a new building in Woodbridge Road, adjacent to the cattle market. A large group of dignitaries, traders and onlookers all posed for the official photograph in front of the iconic building.

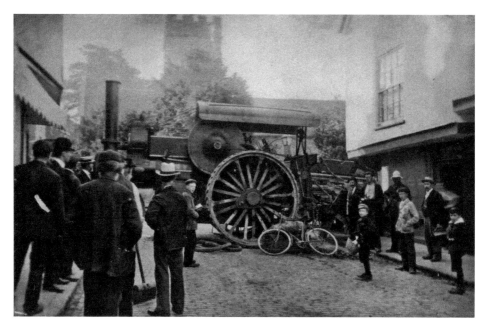

A steam traction engine and its trucks blocked Quarry Street, near St Mary's Church, on 20 July 1904. It was being driven by Royal Engineers and slipped on the granite setts, resulting in one of its trucks containing a load of heavy steel rails to overturn.

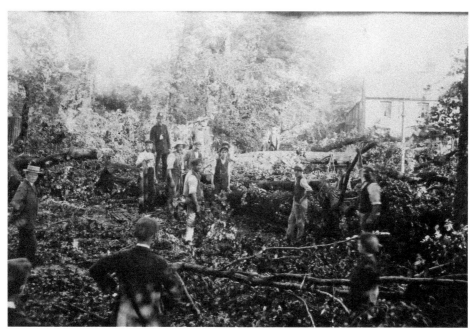

A terrific storm hit Guildford on the evening of 2 August 1906, claiming the lives of Charles Voice, aged fourteen, and Ruth Blunden, twenty-three. They died when trees they had been sheltering under in Woodbridge Road fell on them. There was thunder, lightning, hailstones and flash flooding. Roofs were torn off buildings, chimney stacks crumbled and there was debris everywhere. This picture shows the clearing up along Woodbridge Road.

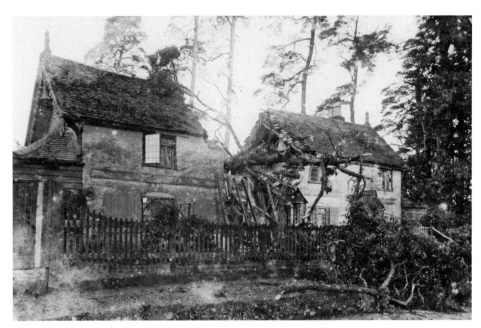

During the 1906 storm a fir tree on the edge of Shalford Park crashed through Park Cottages along Shalford Road. A bedridden man inside one of the cottages, named by the *Surrey Times* as Mr Comber, aged seventy-eight, amazingly survived the ordeal with little more than suffering from shock. The cottages were rebuilt with no sign today of ever having been almost split in two.

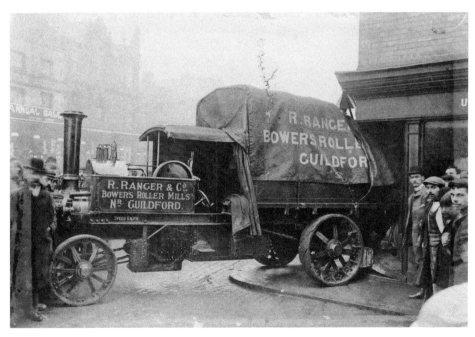

This steam lorry grabbed the headlines in January 1907 when it crashed into an undertaker's shop in North Street. The vehicle belonged to R. Ranger & Co., millers of Burpham. It had been parked outside corn merchants Bowyer & Baker, but moved backwards with its driver unable to stop it, smashing the window of A. E. Edwins & Sons' premises.

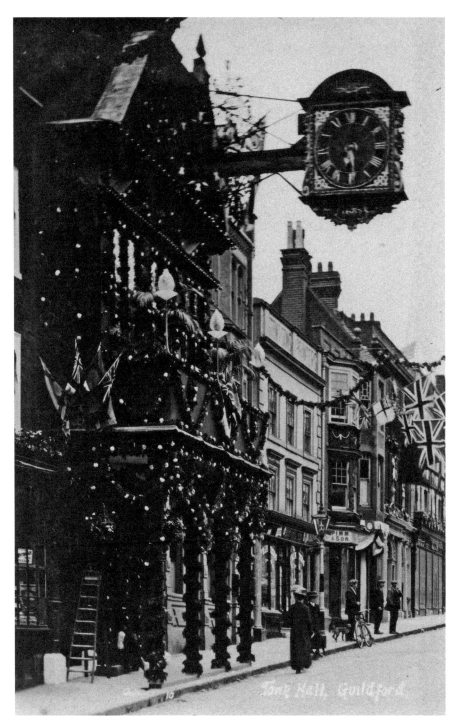

The Guildhall in the High Street, lavishly covered with drapes, flags and other decorations to mark the coronation of George V, which took place on 22 June 1911. The Town Bridge was illuminated and many other buildings and streets were decorated. There was a gun salute from the castle keep, church services, concerts and partying.

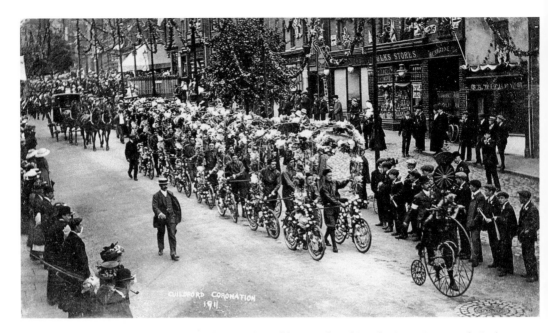

A huge parade billed as 'Historical, Allegorical, Emblematical and Trade Cars, Decorated Cycles, and Characters in Costume' wended its way through the town centre and was watched by many Guildfordians as part of George V's coronation celebrations. Local clubs and societies took part, including the Charlotteville Cycling Club, seen here.

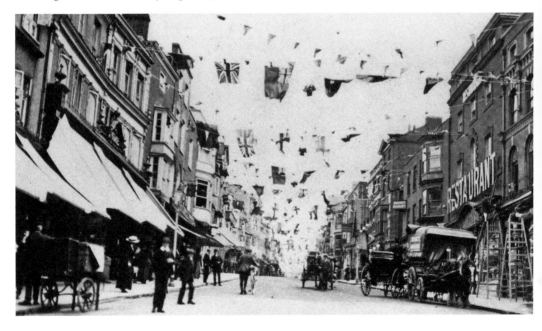

The Royal Counties Show was held on land at Stoke Hill, now Bellfields estate, from 11 to 14 June 1912. The agricultural show must have been much anticipated as the town was again highly decorated to welcome its arrival. This included the High Street as well as Chertsey Street and Stoke Road, along which many of the 35,000-plus showgoers made their way to it.

There was trouble in Guildford town centre on 22 July 1913 when contingents of the Pilgrims' Suffragists (non-militant campaigners for votes for women) passed through Guildford on their way to a mass rally in London. From within the 8,000 onlookers there were catcalls and shrill whistles. A wagonette, being used as a platform for speakers, was almost toppled over. The women had to be rescued by the police and the meeting was promptly ended.

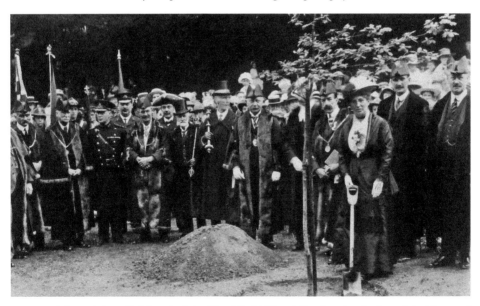

Britain celebrated the official end of the First World War, following the signing of the Treaty of Versailles, with a public holiday on 9 July 1919. In Guildford there were civic and public events, including the planting of an oak sapling in the Castle Grounds, known as the Peace Oak. The tree survived until it became diseased and was felled in around 1970.

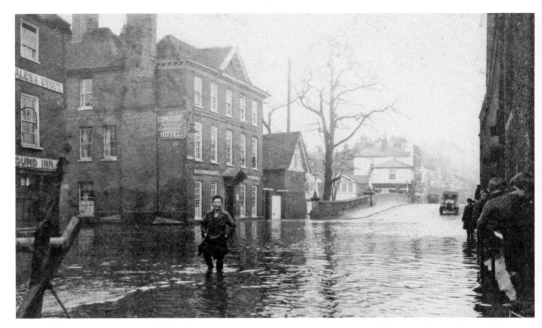

Guildford witnessed a heavy fall of snow over the Christmas period in 1927. New Year's Day 1928 saw a rise in temperature. Rain fell on 2 January and by the next day, when this picture was taken on the west side of the Town Bridge, the River Wey had burst its banks and the lower part of the High Street was flooded.

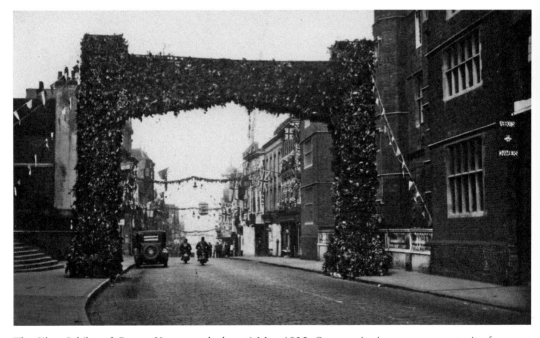

The Silver Jubilee of George V was marked on 6 May 1935. Once again, it was an opportunity for Guildford to hang out its flags and banners in honour of the monarch. In the High Street, in front of Holy Trinity Church on one side and Abbot's Hospital on the other, a large arch covered in greenery was erected.

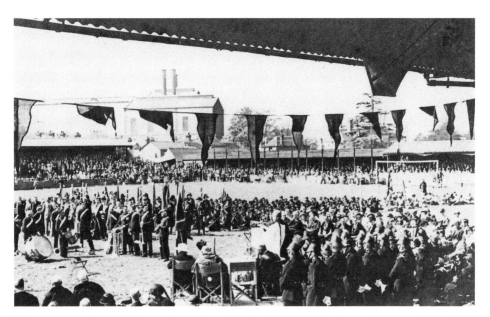

There was a well-attended open-air service of thanksgiving to mark George V's Silver Jubilee, held at Guildford City Football Club's ground in Joseph's Road. Football matches there also attracted many fans. The original club folded in the mid-1970s after the ground had been controversially sold in 1974, to be developed with housing by 1977.

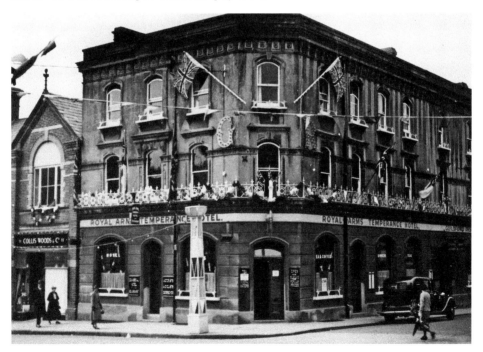

Following the abdication of Edward VIII, his brother was crowned George VI. Celebrations in Guildford for his coronation on 12 May 1937 included flags being hung from a number of town centre buildings, many of which were also illuminated at night. The Guildford Institute and the Royal Arms Temperance Hotel building is seen here suitably decorated for the celebrations.

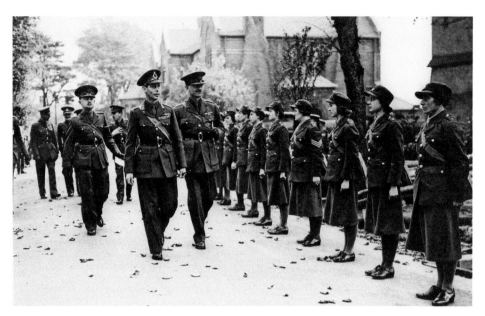

Stoughton Barracks, the depot of the Queen's Regiment, became a hive of military activity soon after the outbreak of the Second World War. On 27 October 1939 George VI visited and watched the training of troops taking place. As seen here, he also inspected a company of women of the Auxiliary Territorial Service. The site is now a housing development called Cardwells Keep, with some of the original buildings and open spaces retained.

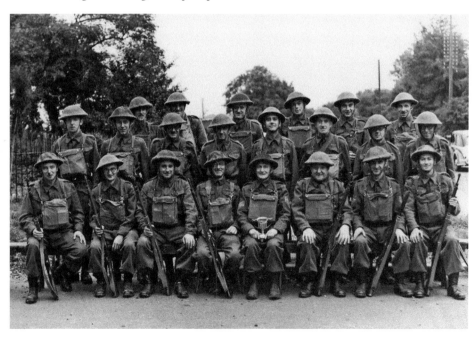

Men of the 4th (Guildford) Battalion Surrey Home Guard did their bit during the Second World War, ready to defend their town against the Nazis. These guarded the Onslow Village area and, like all platoons, included men too old or too young to join the armed forces, or those engaged in reserved occupations for the war effort.

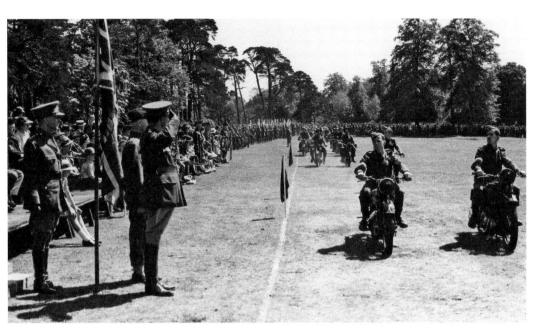

It wasn't all drill, training and monotonous guard duties for the Home Guard volunteers. On 16 May 1943, to celebrate the second anniversary of it forming, a ceremonial parade was held at Shalford Park. In front of a large crowd, the Home Guards gave a demonstration of the weapons with which they were armed. The reviewing officer was the Lord Lieutenant of Surrey, Sir Malcolm Fraser.

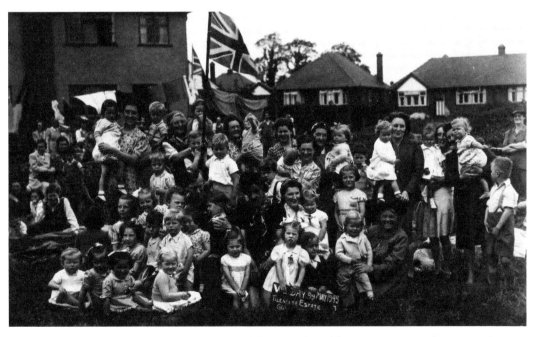

When peace finally came in May 1945 to end the Second World War in Europe, and in August that year when Japan was defeated, there were celebrations and parties throughout Britain. Children, some with their parents and grandparents, fill the scene here at a VE Day party that was held on the Tilehouse estate at Stoughton.

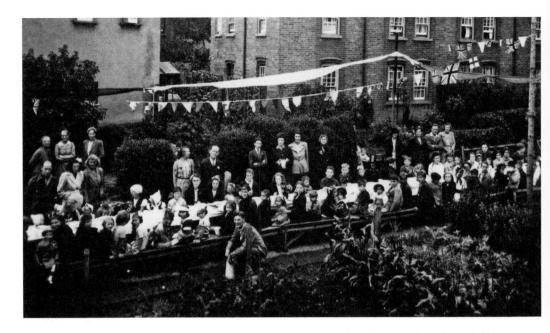

Trestle tables and benches have been lined up in the road at Shepherds Hill in Stoughton for a children's party celebrating the end of the Second World War. Everyone gazes at the camera for a snapshot of a moment in time. Many of these children would have been too young to have known what life was like before the war.

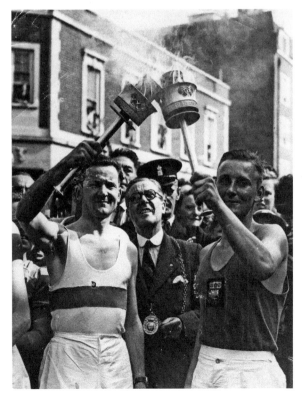

Britain stepped up to host the first post-war Olympics – held in London in 1948. The Olympic torch relay started at Dover, with runners carrying it through the south of England to Wembley Stadium. Local athlete Austin Playfoot (dark vest) lights fellow runner Frank Ede's torch at a handover point in Guildford's upper High Street. Pictured with them is the then Mayor of Guildford, Alderman Arthur Williams. Playfoot had started his leg of the relay at the Horse and Groom pub in Merrow.

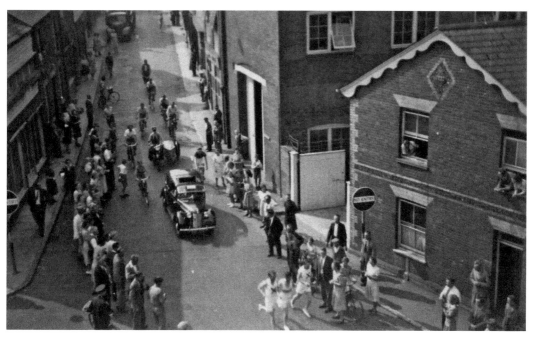

This picture is believed to show the 1948 Olympic torch relay continuing along Woodbridge Road (with Leapale Road off to the left) on its way to Stoughton, where Frank Ede handed over the torch to another runner. There had been some rowdy scenes in the upper High Street with onlookers pushing and shoving one another to get a better view.

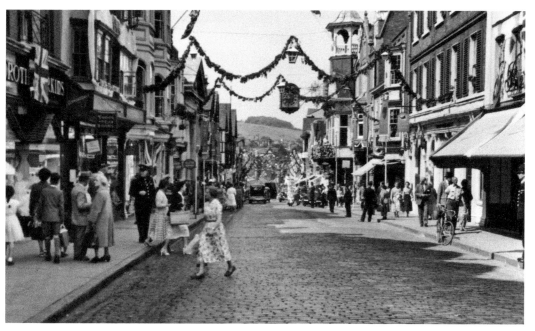

Elizabeth II ascended to the throne on 6 February 1952, and her coronation took place on 2 June 1953. This view shows the High Street at the time of her coronation. It is evident that the decorations in the town were not so lavish as they had been for the celebrations of past coronations and jubilees.

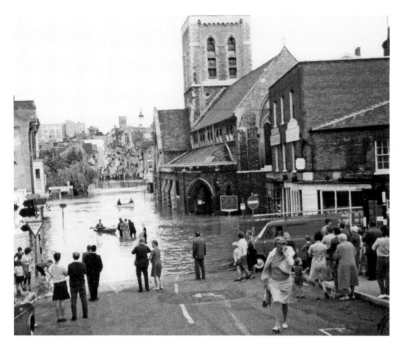

St Nicolas Church is surrounded by water, with plenty of onlookers, during the floods of September 1968. It was said at the time these floods were on a scale that would only occur once in a thousand years. The lower part of the town has since been flooded several times, including in 1990, 2000 and 2013, but the waters have not been so deep.

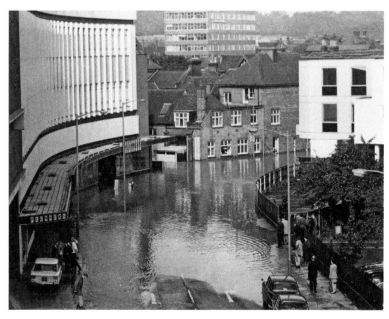

Rain fell during the evening of Saturday 14 September 1968 and continued most heavily throughout the Sunday. In the early hours of Monday, the swollen River Wey, as its waters passed through Guildford town centre, burst its banks. This view shows Millbrook and the then new Plummers store under water.

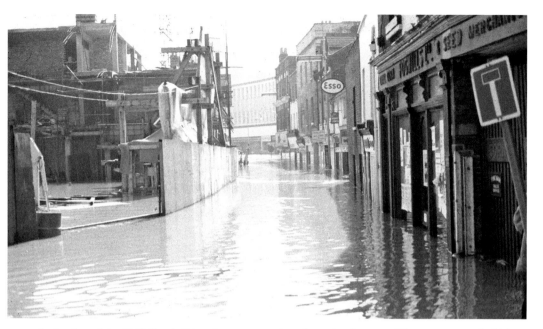

At the time of the 1968 floods Friary Street was undergoing redevelopment. The water was at its highest around the time of the Monday afternoon, by which time the skies had brightened up. Many people came into the town centre that afternoon and evening to witness the spectacle and take photographs, including David Salmon, who took this picture.

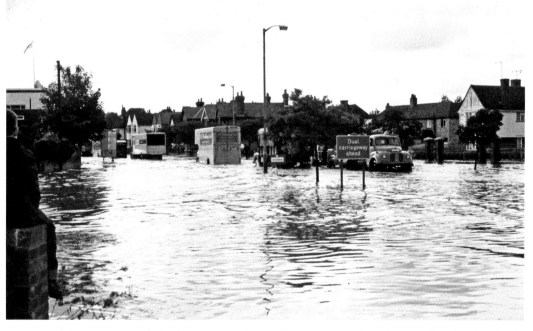

Low-lying areas around Guildford near the River Wey also caught the full force of the floods. Here in Ladymead traffic manages to make its way through the water. The houses in the background no longer exist, having been replaced by the Ladymead Retail Park.

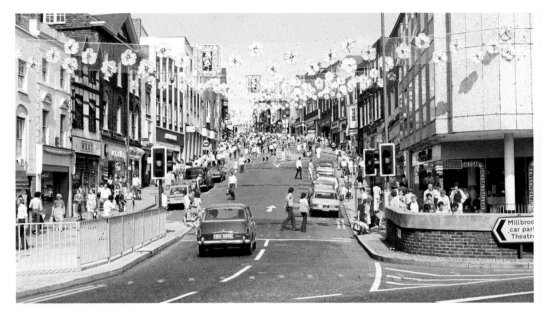

The decorations strung across the High Street to celebrate the Queen's Silver Jubilee in the summer of 1977 look spectacular. They included flowers and plaques that featured lions and unicorns along with symbols of Guildford's royal connections and its history. Some of the plaques survive and one is on display in Guildford library. There were street parties, fêtes and shows. A beacon was lit on The Mount on Sunday 7 June.

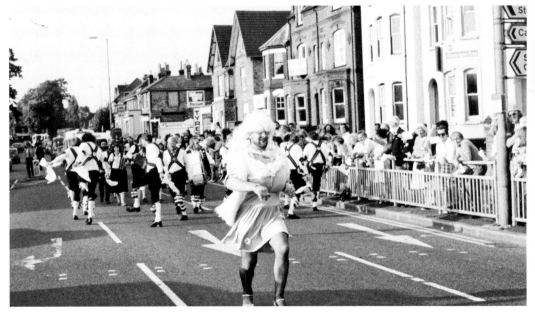

For several decades from the 1950s onwards the Guildford Town Show was held in Stoke Park in the September of each year. A popular feature was a carnival procession through the town to the showground. The streets were lined with people watching the decorated floats of local groups, societies and businesses, as well as bands; and, as seen here in Woodbridge Road in 1982, Guildford's Pilgrim Morris Men behind a man in drag.

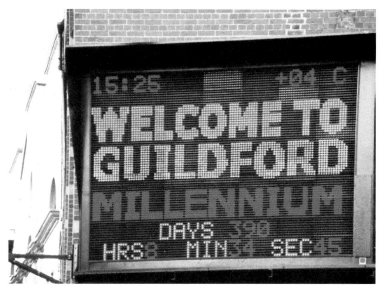

Those who wished to celebrate the millennium in Guildford had a choice of where to stand when midnight approached and the year 2000 was heralded in. A large electronic countdown clock was installed on the side of Michel Harper's nightclub in Onslow Street. The *Surrey Advertiser* sent a young reporter to stand there as the minutes and seconds ticked away. He later reported the crowd there had been rather sparse, while many more had gathered under the Guildhall clock in the High Street.

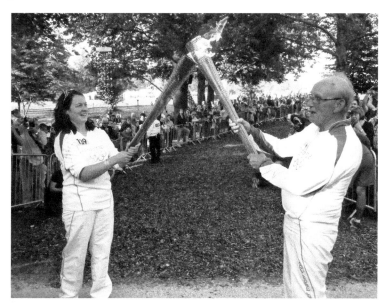

The Olympic torch relay returned to Guildford in 2012 when London hosted the games once again. This time it travelled around much of the country and perhaps Guildford was fortunate to have the flame come here once more on Friday 20 July, with 25,000 people enjoying a party with music and entertainment in Stoke Park. It was fitting that 1948 torchbearer Austin Playfoot was on hand again. He is pictured here at the handover from Ellie Messham, from which he jogged the last part of the Guildford leg through the park.

6

Sports and Recreation

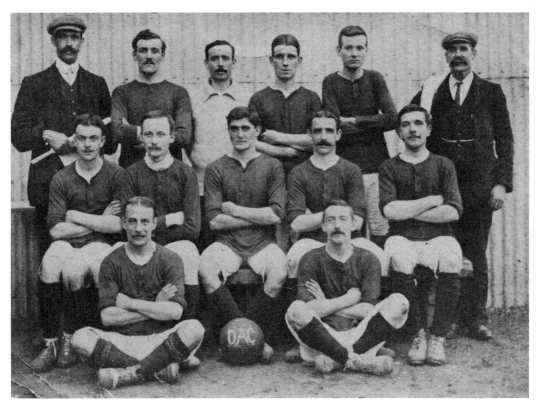

It was around the late 1870s and early 1880s that competitive sports appeared to have gathered pace in Guildford. One of the town's first football clubs was the Guildford Pinks, who were formed in 1877. By the early 1900s clubs were being formed by men who were working in local factories. The letters on the ball, 'D.A.C', reveals this is most likely a team of the Dennis Athletic Club – the team of the specialist vehicle manufacturer Dennis Bros.

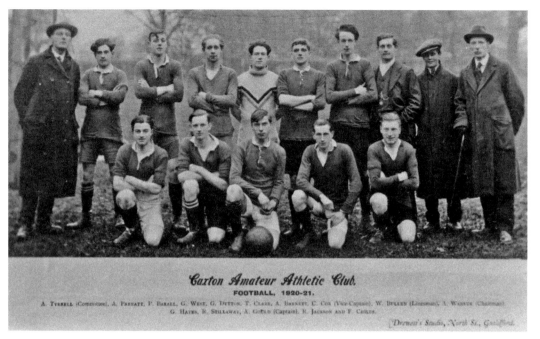

Caxton Amateur Athletic Club.
FOOTBALL, 1920-21.

A. Tyrrell (Committee), A. Parratt, P. Harall, G. West, G. Dutton, T. Clark, A. Barnett, C. Cox (Vice-Captain), W. Bullen (Linesman), A. Warner (Chairman). G. Hayes, R. Stillaway, A. Gould (Captain), R. Jackson and F. Childs.

[Dremen's Studio, North St., Guildford.

Players of the Caxton Amateur Athletic Club's 1920–21 season are featured in this picture. They would have worked for the printers Billings, whose works was in Walnut Tree Close. A Guildford-born lad by the name of Ronnie Rooke was signed by Arsenal in 1946 for £1,000, scoring sixty-eight goals in eighty-eight league games. As a boy he practised his football skills kicking a tin can around the back streets of the town.

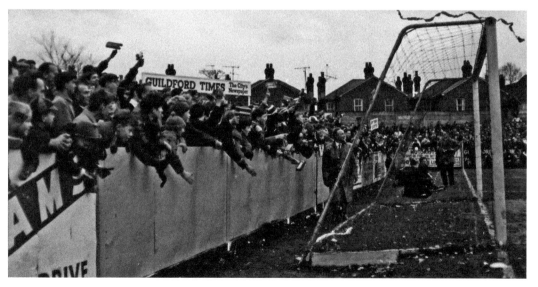

The original Guildford City Football Club, with its ground in Joseph's Road, was formed in 1921 as Guildford United. It changed its name to 'City' to coincide with the formation of the Anglican diocese of Guildford in 1927. Some people thought the town of Guildford would become a city as soon as its cathedral was built. City status in the UK can only be granted by the monarch. Many people today wrongly believe that Guildford is a city, but it is, of course, a borough.

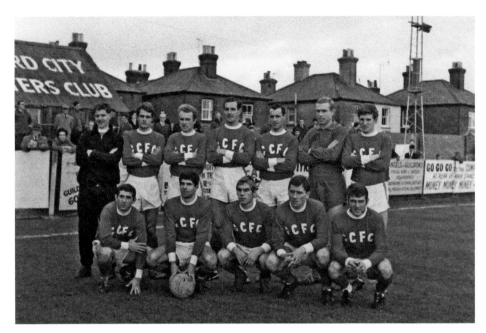

The semi-professional Guildford City played in the Southern League, winning the league title in the 1937–38 and 1955–56 seasons. The glory days continued with the club winning the Southern League Cup in the 1962–63 and 1966–67 seasons. Many star players from the 1960s are in this line-up, including striker Tony Burge (third from left, front row). And on the far right of the same row is defender Derby Watts, who played around 650 games for City and even managed the team for a short spell in 1973.

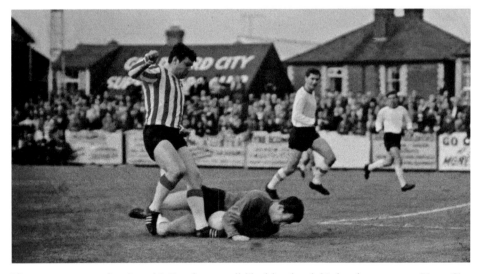

The compact ground at Joseph's Road was well liked by the club's loyal supporters. Here, City (in the red-and-white stripes) play Woking in the FA Cup, 1965–66 season. With financial problems mounting, it all went wrong for the club after the ground was sold for £40,000 in 1970 to Guildford and Surrey Investments, and was resold two years later to Joviel Properties for £200,000. The final match at the ground was a 2-0 win against Folkestone on 12 February 1974. The site was developed for housing in 1977.

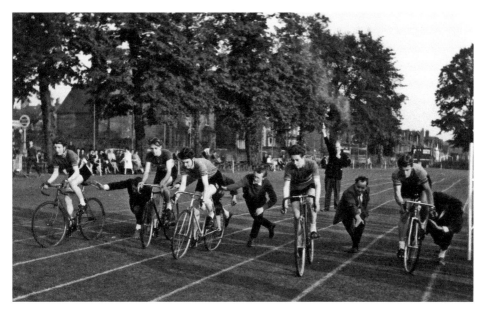

Cycling as a sport grew in popularity from the latter part of the nineteenth century as people gained more leisure time and bicycles became more proficient. Local clubs were formed, staging road races and time trials to places such as Oxford and Brighton. Track racing is seen here at the Woodbridge Road sports ground in the 1960s. Today's annual town centre cycle races are organised by the Charlotteville Cycle Club.

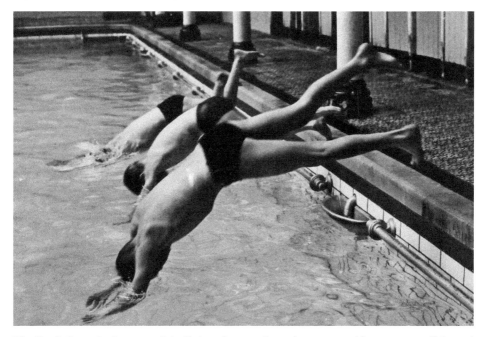

The Castle Street Baths were originally just that – a place where you could go, pay a small fee and have a hot bath to wash in. Built with a swimming pool as well, this Victorian creation adjacent to the Castle Grounds lasted until the Guildford Sports Centre was opened in 1972. Here, three people dive into the waters in around the 1950s.

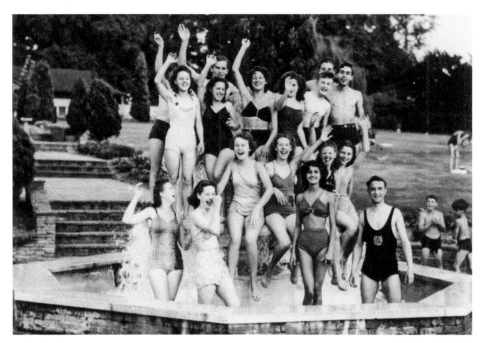

The Guildford Lido opened in 1933 and was an instant success, drawing scores of bathers to the open-air venue near Stoke Park, as long as the weather was fine! Still as popular today, a few features have been lost or replaced over the years, such as several fountains that appear to have been rather popular indeed.

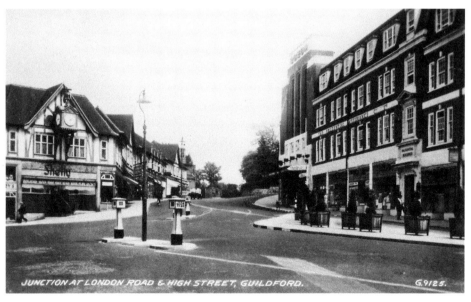

By the 1930s going to 'the flicks' was well and truly a national pastime. By no means the first cinema in Guildford, the Odeon opened at the top of the town in Epsom Road on 13 May 1935. Its art deco façade became something of a landmark, but is now gone since the site was redeveloped. Gone too are cinema commissionaires who once patrolled the long queues of people waiting to get in, keeping them in order.

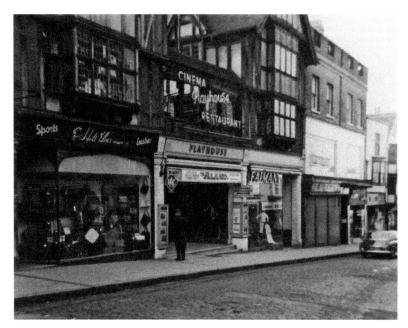

When it opened in the 1920s, the Picture Playhouse arcade boasted having shops, a restaurant, a club, winter gardens and a theatre. A cinema soon replaced the theatre and proved popular for many years, showing its final film in 1965, after which it was replaced by a supermarket. The whole retail site was redeveloped in the 1980s and again in 2017–18 and renamed Tunsgate Quarter.

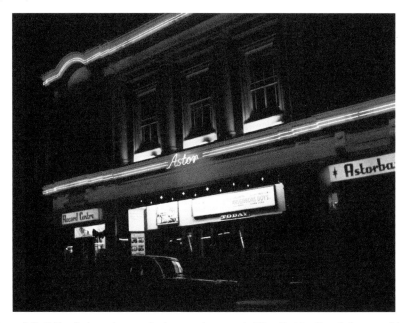

Another of Guildford's lost cinemas is the one that was in Woodbridge Road. It opened in 1922 as the Cinema, then becoming the Astor and finally Studio 1 & 2. In the 1990s the building was turned into a live music venue called Flicks, ending its days as a nightclub and going by the name of Bojanglez.

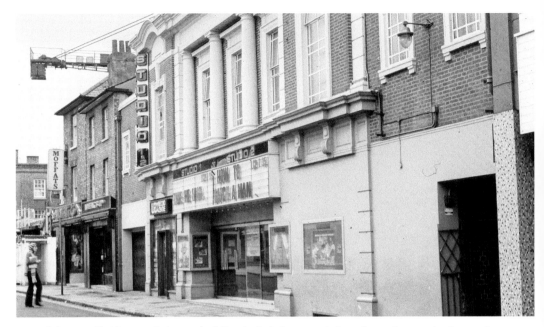

Part of the Woodbridge Road cinema building included a record shop. It can be seen in the previous picture – named Record Centre. By the time this photo was taken in 1974, it was named Wax Record Centre. Outfitters Moffats' shop can also be seen next door.

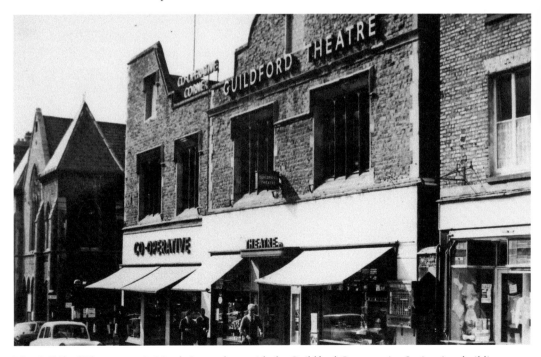

The Guildford Theatre was in North Street along with the Guildford Co-operative Society in a building with some history. It had once been the County and Borough Halls, the town's first purpose-built meeting place. A fire in 1963 badly damaged the theatre and it never reopened. The Yvonne Arnaud Theatre by the river replaced it, which was opened in 1965.

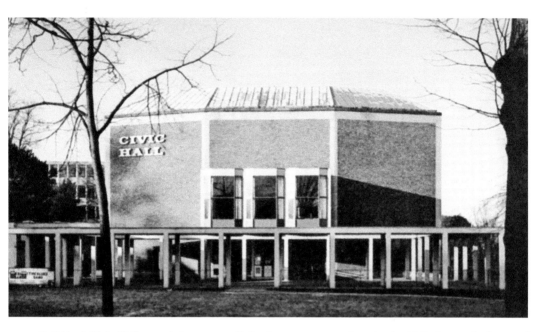

Guildford Civic Hall served the town well for forty-two years. Opening in 1962, it was the home of the now-defunct Guildford Philharmonic Orchestra. Many legendary pop and rock music artists also played there. The concert in 1973 by David Bowie as his alter-ego Ziggy Stardust is rated by many as an exceptional concert. The hall was replaced by G Live, which opened in 2011.

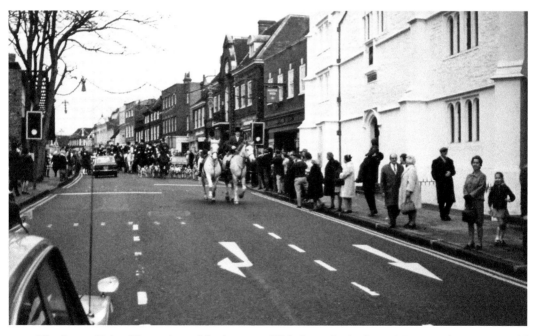

The Surrey Union Hunt, pictured in the upper High Street in the late 1960s or early 1970s, would traditionally gather on Boxing Day outside the Civic Hall. Opponents of fox hunting became more and more vociferous and active until the late Bernard Parke, when serving as mayor, cancelled the Boxing Day event in 1989 because of expected trouble. In 2004 fox hunting was made illegal.

7

The Town at Work

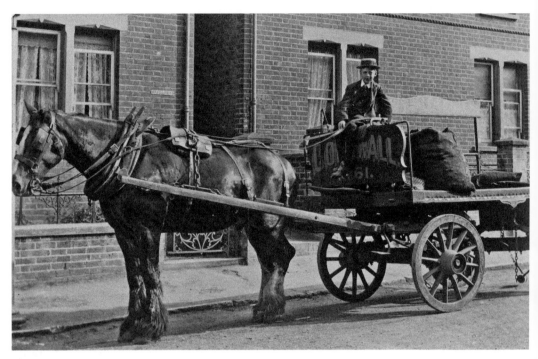

The coalman was once a familiar sight delivering to households and businesses. Pictured here in a street in Guildford in the early 1900s is Cornwall's Coals' horse-drawn cart. Coal and coke merchants operating in Guildford in the 1960s included Franks & Co., the Co-op, Ellis & Sons of Worplesdon, Luck & Son of Normandy and Tyne Main of Farncombe.

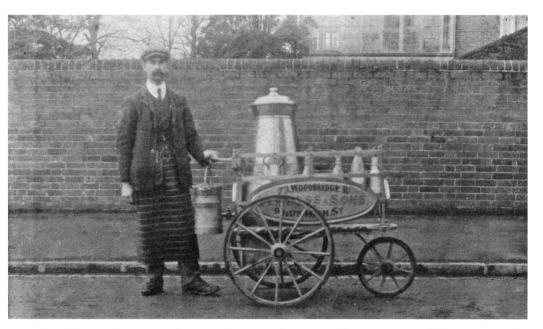

The dairyman did his rounds with a handcart, dispensing milk from a churn. This was before the introduction of milk bottles in around the 1920s. As written on the cart, Lymposs & Sons had premises in Woodbridge Road and High Street. The firm later merged with another Guildford dairy to become Lymposs & Smee.

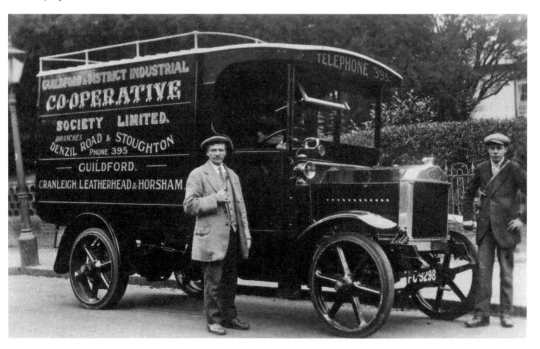

Established in 1891, the Guildford & District Co-operative Society grew rapidly with its main shop and offices in North Street and Haydon Place. This delivery lorry (made by Dennis Bros of Guildford) dates to around the early 1920s, and proclaims the society's numerous branches at that time.

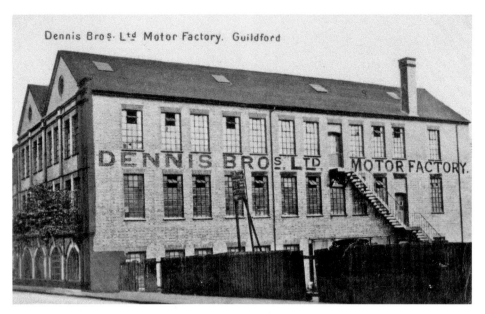

Dennis Bros. Ltd Motor Factory. Guildford

By 1901 brothers John and Raymond Dennis needed larger premises to build their motor vehicles. Seeing a factory building being constructed on the corner of Bridge Street and Onslow Street, they acquired it. It was taken over by the Rodboro Boot & Shoe Company in 1919 and over the years has had many occupants. Its use for manufacturing has long gone, it now being a JD Wetherspoon's pub and home to the Academy of Contemporary Music.

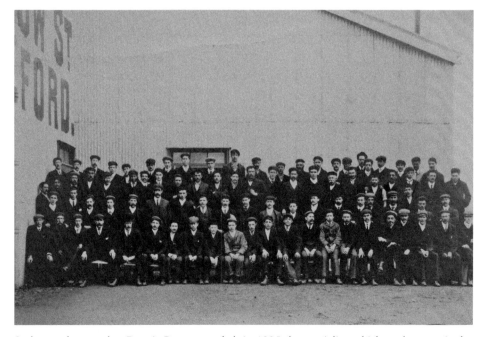

Such was the rate that Dennis Bros expanded, in 1905 the specialist vehicle maker acquired a large site near the foot of Woodbridge Hill. The workers seen here are in front of its first building erected there. It had been the Torre-Alexander Mission Hall that had stood in Brixton. It was dismantled piece by piece, brought to Guildford and reassembled.

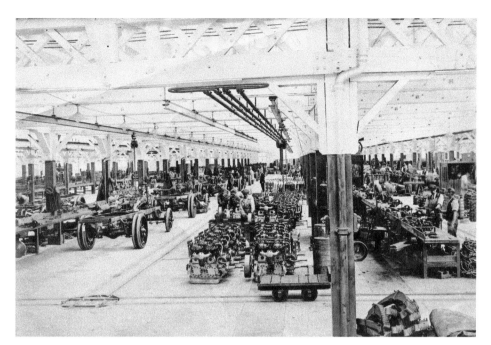

During the First World War Dennis Bros made 7,000 3-ton lorries for the War Department as the Woodbridge Hill factory continued to expand. There were, however, difficult times in the 1920s, but production did eventually pick up with sales of its buses and fire engines.

Dennis Bros attracted skilled workers from far and wide and put the town on the map as a centre for light engineering. During the Second World War Dennis' workforce doubled from 1,400 employees to 3,000, making munitions that included trailer pumps for fire engines and Churchill tanks.

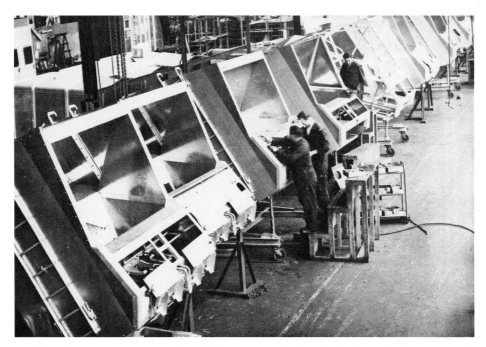

The Hestair company took over Dennis Bros in 1972. Although vehicle production was much reduced, the firm did win a Queen's Award for Export in 1977. The firm has survived and is now Alexander-Dennis, a worldwide bus and coach builder. Since 1991, its Guildford factory has been at the Slyfield Industrial Estate. In 2019 the firm was acquired by North American bus maker NFI Group Inc. Refuse collection vehicles continue to be made by a separate firm, Dennis Eagle, based in Warwick.

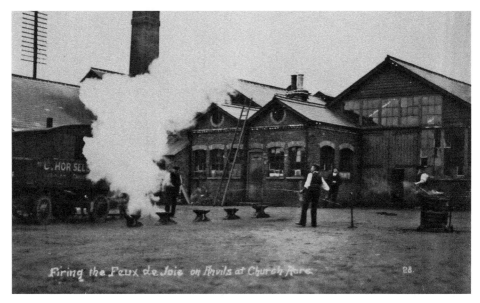

Market towns like Guildford once had firms who made all kinds of metal products, from items for local farmers to those found in and around the town. Dickinson & Burne's Church Acre iron foundry was in Leapale Lane. Gunpowder is being set alight from five upturned anvils, an old tradition at the time, to celebrate the coronation of George V in 1911.

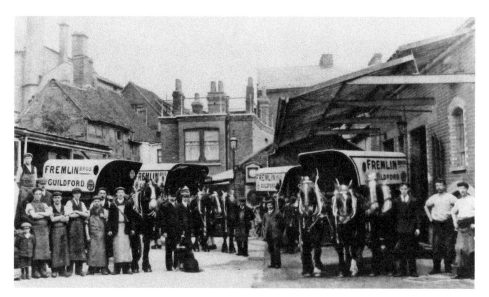

Not only could Guildford once boast several of its own breweries, other brewers also had depots in the town – such was the demand for beer! Fremlin Bros brewed in Maidstone, Kent, while its Guildford depot was off North Street, where Phoenix Court is today. Fremlin's continued to have a presence in Guildford with a store at that location until the early 1960s.

The town's first electricity-generating station was built in 1896 by the Guildford Electric Supply Company. It was enlarged in 1913 and is now the Electric Theatre building by the riverside. By the 1920s the original power station couldn't cope with demand, resulting in this much larger coal-fired power station being built in Woodbridge Road (nearly opposite Recreation Road) and working by 1928. It lasted until 1968. Other electricity company buildings were then built on the site, but were demolished in 2003, replaced by further office buildings and homes.

The timber yard seen here in the late 1950s belonged to John Moon & Son Ltd, and was known as St Mary's Wharf. The location is recognisable today as in the background is the former Town Mill, now the Mill Studio annexe of the Yvonne Arnaud Theatre. The Debenhams store, which opened as Plummers in 1968, was built on the site of the timber yard.

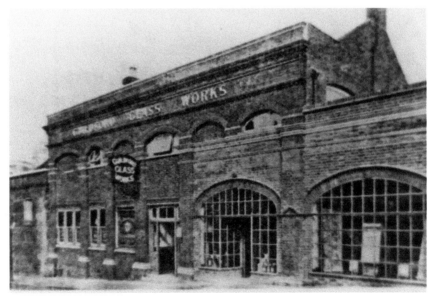

Photographs of Lascelles, Tickner & Co.'s Castle Brewery, which occupied a site between Bury Street and Portsmouth Road, are extremely rare. However, there are a few pictures of the nineteenth-century building when it was in use by the Guildford Glass & Metal Works. It took over much of the site after the brewery closed in 1927, remaining in business there until the end of the 1950s. Burymead House office block (since demolished) was built on the site.

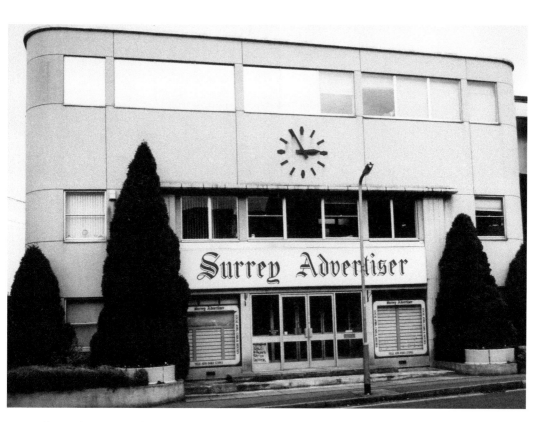

Above: The *Surrey Advertiser & County Times* newspaper moved into modern purpose-built offices and printworks in Martyr Road in 1937. The art deco-style building was faced with cream faience tiles. These were largely removed in the early 1980s and the walls then rendered. The original metal-framed windows were also replaced, and this is how it looked in its final years.

Right: Like many trades in years gone by, to become a qualified printer took a seven-year apprenticeship. The print trade had its own tradition in that the newly qualified went through an initiation ceremony. The rite of passage, known as 'banging out', included having a bin of slops (too disgusting to list) tipped onto the unfortunate person and then being paraded around the town centre tied to a printer's barrow. A *Surrey Advertiser* printer is pictured here.

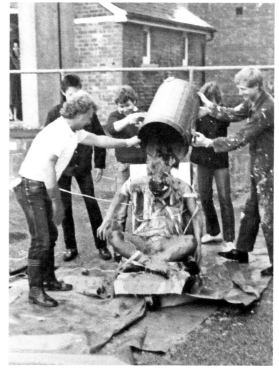

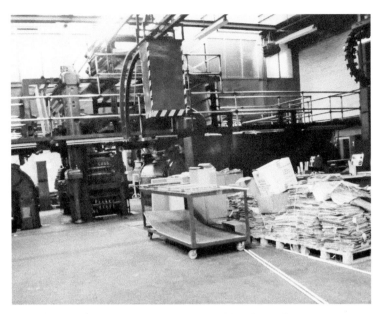

A late 1950s extension to the *Surrey Advertiser*'s building housed its printing press – a Goss Headliner Mark II. It served the newspaper group well until printing in Guildford ceased in 1992, being transferred to a press in Reading that was able to print in full colour. The 'press hall', as it was known, fell silent as seen here, and remained so for several years before the buildings were demolished.

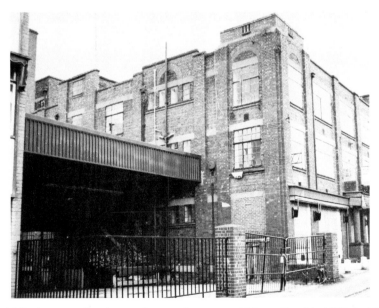

Printers Biddles began trading from a shop on the corner of Martyr Road in 1885. In 1923 it had a large works built further along the road. A shop selling stationery was on the ground floor with printworks on the first and second floors. It too once published a local newspaper – the *Surrey Weekly Press*, popular between the two world wars. The works closed down in 1989 and the site, with the adjoining *Advertiser* site, is now occupied by apartments, called Printing House Square. Biddles of Guildford stationers now trades in Ward Street.

Jackson's Garage was in the High Street where Millbrook is today. It once had a team of mechanics who did a full range of servicing and repairs to motorcars. Later moving to a showroom in Onslow Street with its servicing and parts department in Walnut Tree Close, it was an agent for Austin, Vanden Plas and Riley vehicles.

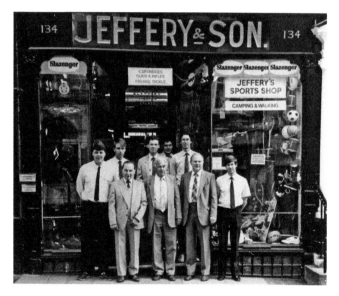

Many people have the very same fond memories of aspects of Guildford that are now lost. Among them is Jeffery's sports shop that was in the High Street. In 1851 Richard Jeffery of Farnham took over the gun-making business of Henry Piper. The business remained in the same family for several generations and many of its loyal staff worked there for decades. Members of staff are pictured outside the shop in about the 1980s, it closed in 2001.

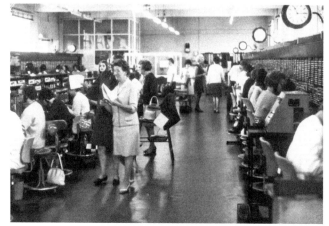

Lastly, a peek inside Guildford's Post Office Telephone Exchange, with its operators (mostly women) busy helping callers with such things as directory enquiries and other telephone queries. How times have changed with today's automated digital phone systems. The telephone exchange building between Leapale Lane and Leapale Road is still in use, but the scene pictured here has been lost forever.

Bibliography

Alexander, Matthew, *Guildford As It Was* (Hendon Publishing, 1978)

Burch, Geoff, *The Ramblings of a Railwayman* (2011)

Burch, Geoff, *Further Ramblings of Railwaymen* (2012)

Collyer, Graham and David Rose, *Guildford: The War Years 1939–45* (Breedon Books, 1999)

Geddes, G. W., *The Guildford Home Guard* (Gale & Polden Ltd)

Mitchell, Jacqueline, *The University of Surrey: A History of Shaping the Future* (University of Surrey, 2011)

Rose, David and Bernard Parke, *Guildford Remember When* (Breedon Books, 2007)

Rose, David, *Great War Britain Guildford Remembering 1914–18* (The History Press, 2014)

Sturley, Mark, *The Breweries and Public House of Guildford* (Guildford: Charles W. Traylen, 1990)

The archive scrapbooks at the Guildford Institute and stories published on The Guildford Dragon NEWS website.